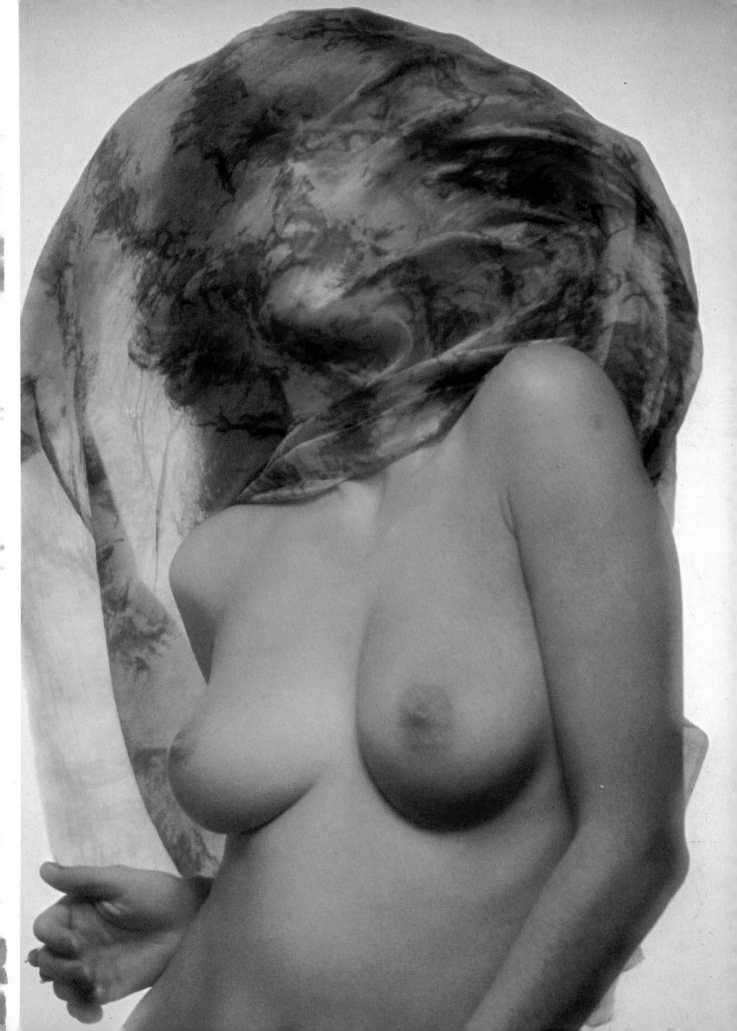

Photographing Sensuality: J. Frederick Smith

text by Sean Callahan
with the editors of Alskog, Inc.

Prepared by Alskog, Inc.
Lawrence Schiller / Publisher
William Hopkins / Design Director
John Poppy / Executive Editor
Sean Callahan / Editorial Coordinator
Ira Fast / Production Manager
Julie Asher Palladino / Design Assistant
Judith R. Schiller / Copy Editor
Lou Jacobs, Jr. / Technical Editor

An Alskog Book
published with
Thomas Y. Crowell Company, Inc.

Library of Congress Catalog Card Number: 75-12934
ISBN: 0-690-00782-5 Soft cover
ISBN: 0-690-00781-7 Hard cover
First Printing
Published simultaneously in Canada
Printed in the United States of America

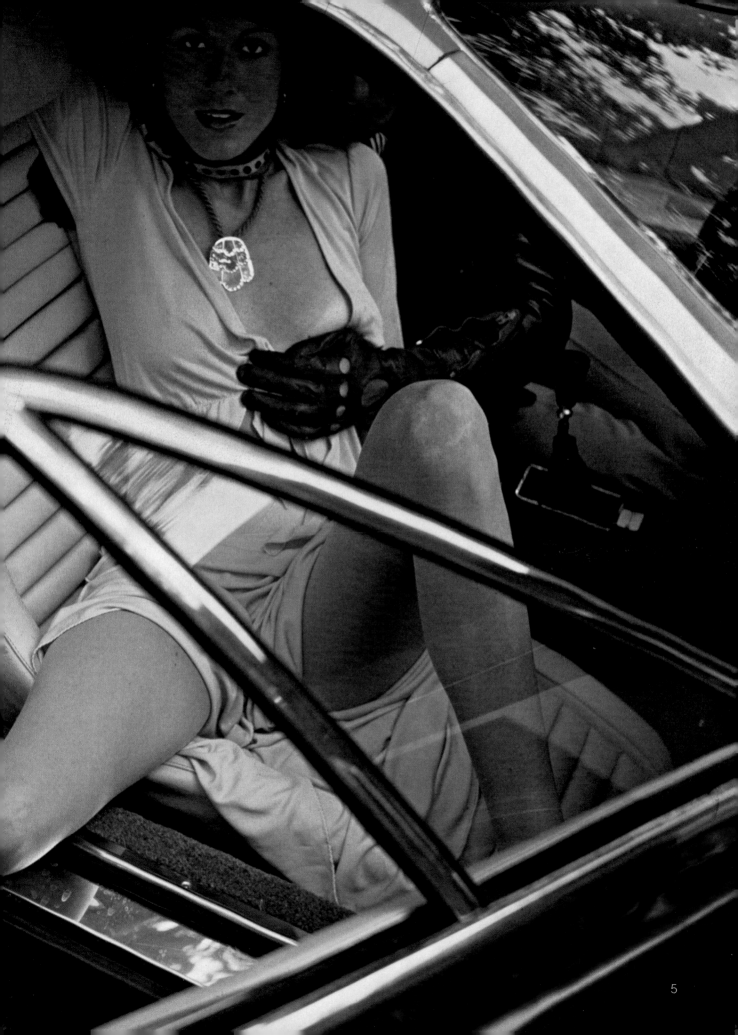

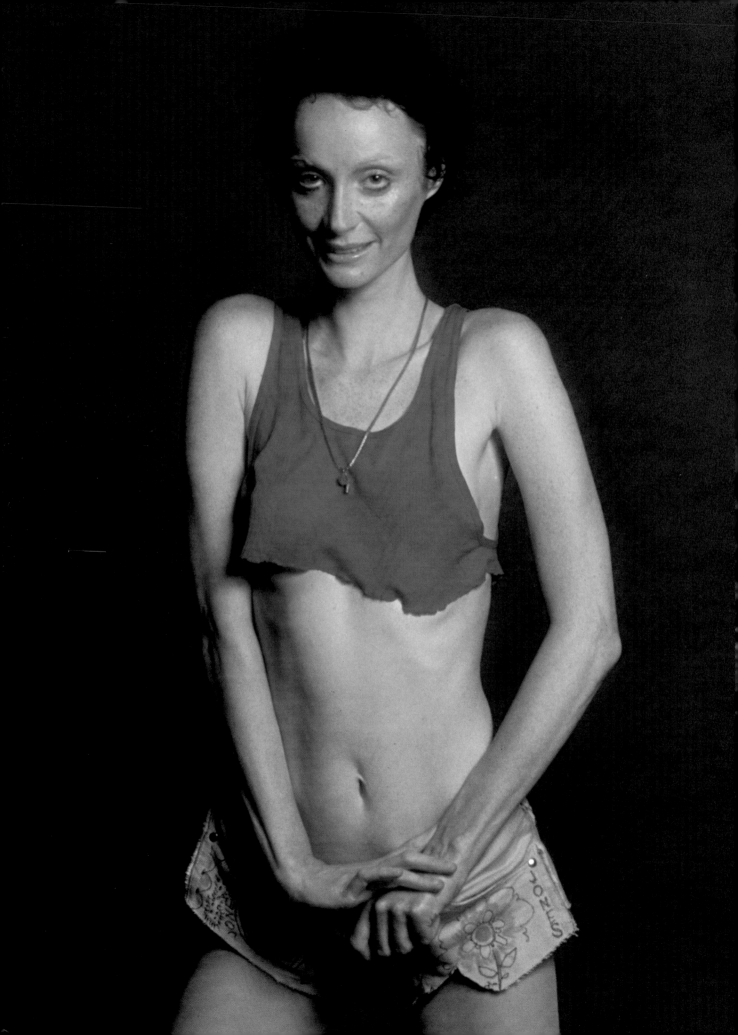

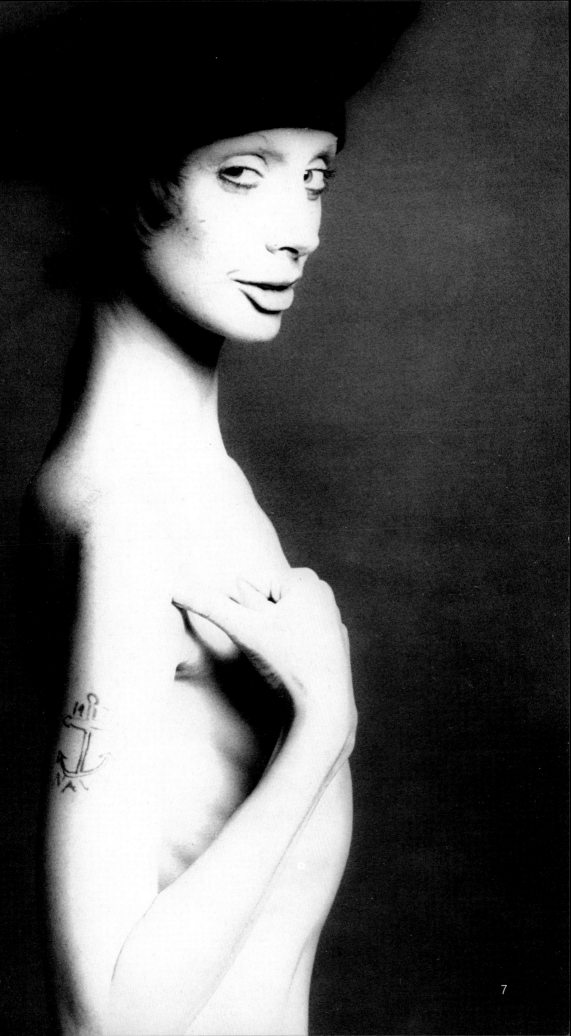

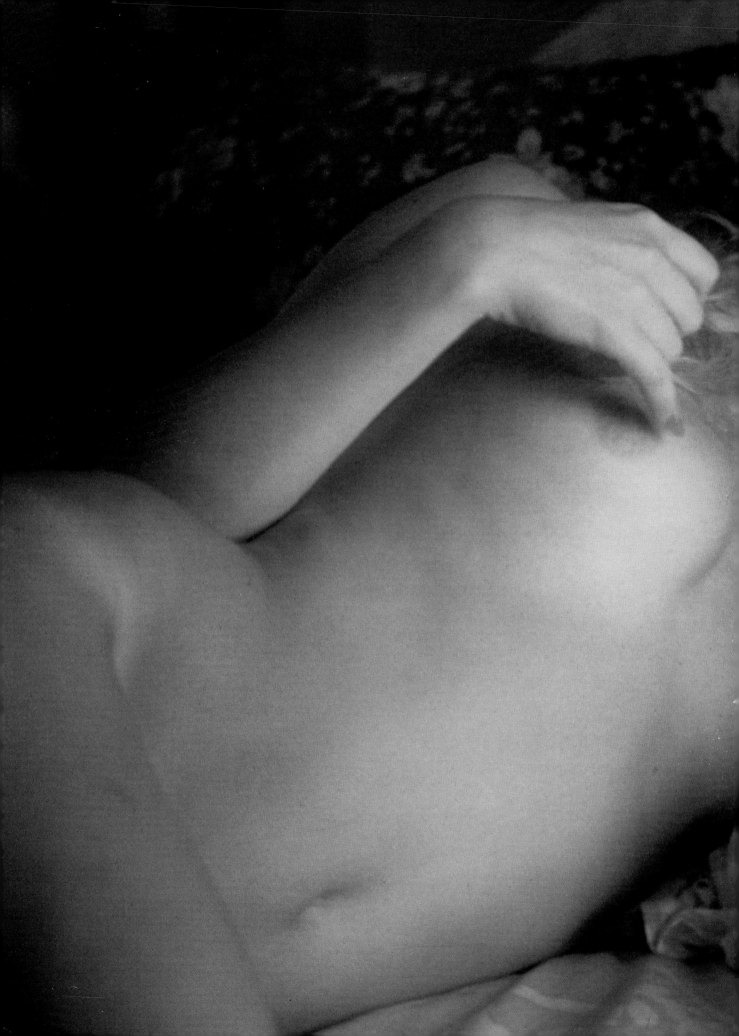

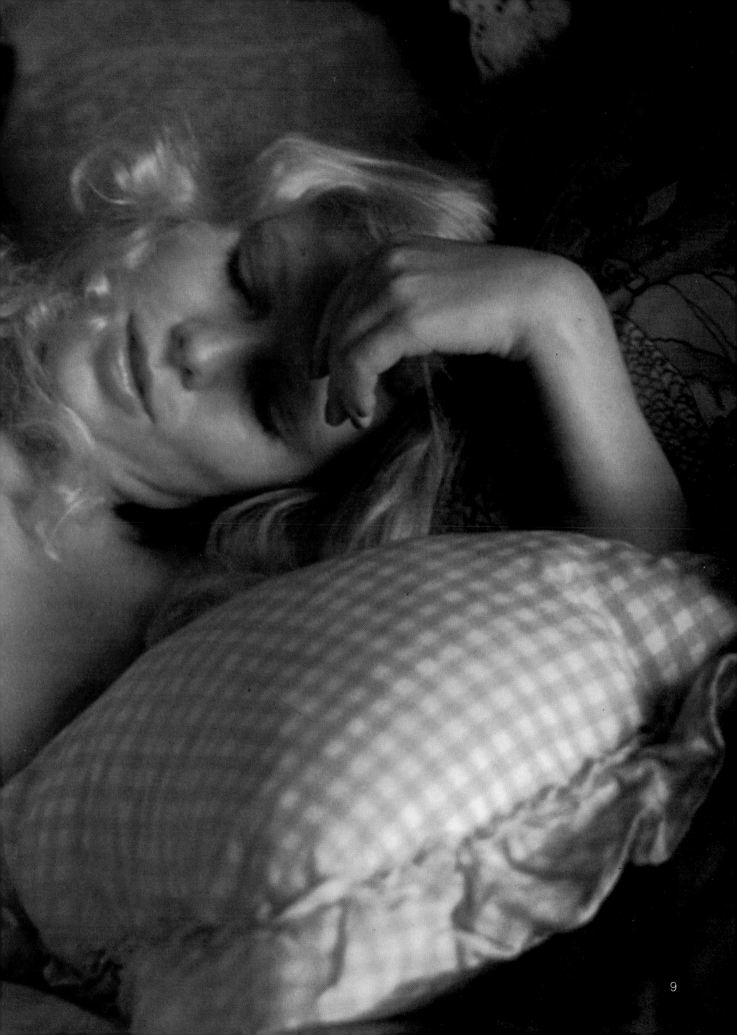

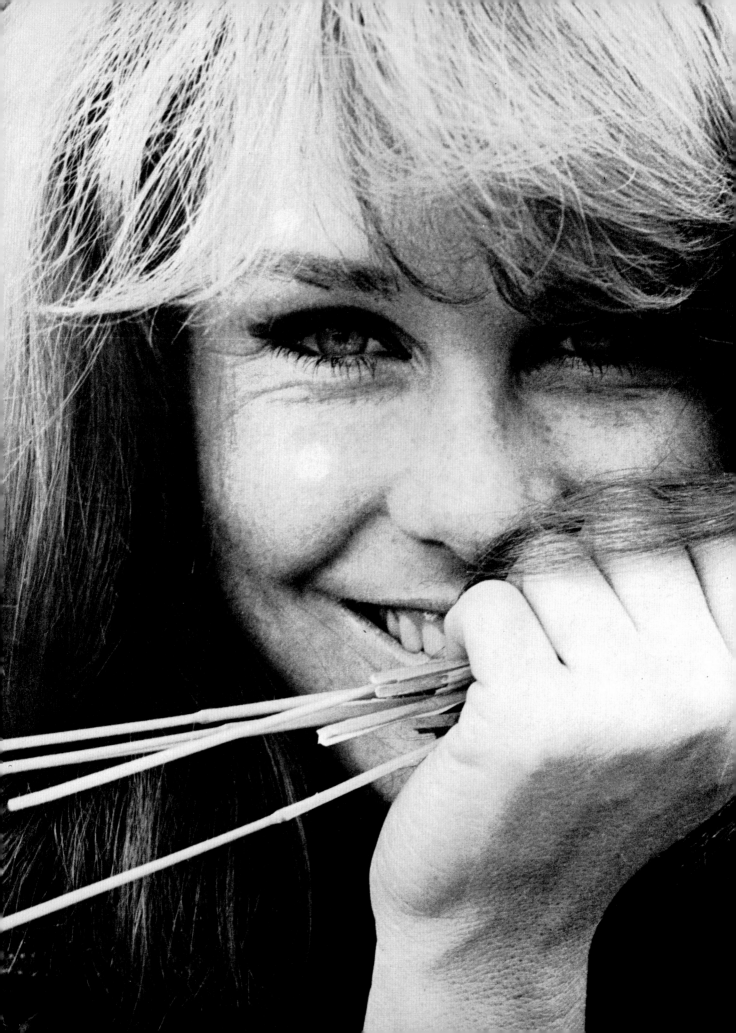

Introduction

Less than a year after the unveiling of the Daguerrean process in 1839, N.P. Lerebours, a Paris optician, made the first photographs of nudes. What became of his pictures is not known. Their subject matter, celebrated by artists for millennia, would be denied to photographers for years to come because the camera stripped the nude naked; that outraged the guardians of public decency.

Early photographers like Eugène Durieu made nude studies, called *académies,* but only for artists such as Delacroix, who posed the models himself. Hence the earliest existing nudes, although life-like, are stiff, formal studies emulating the painting of the day.

O.G. Rejlander, a Swedish-born photographer working in London, made the first nudes in Britain in 1857. Rejlander, one of the most celebrated "art" photographers of the 19th Century, climaxed his career with a composite print entitled "The Two Ways of Life." It featured many nudes and caused such controversy that he soon gave up photographing for the public, preferring instead to provide artist's studies which barely supported him until his death in 1875.

In America, one of the foremost painters of the era, Thomas Eakins, saw photography as an important aid to his anatomy classes at the Pennsylvania Academy of Art. He became an ardent photographer and produced some female nudes as frank and finely detailed as his paintings. Yet his uninhibited use of the nude in photography as well as in his painting classes forced his dismissal.

After the turn of the century, "photo-secessionist" photographers led by Alfred Steiglitz showed such serious purpose that their nudes were tolerated—partly because of a vagueness at representing the female form that was achieved by soft focus, celluloid diffusion filters and textured printing papers. The First World War shattered the remnants of Victorian prudery. A new freedom let to a hard-edged realism best typified by the pictures of Edward Weston, whose severe aesthetic reduced the model to a mere object and often times lopped off her head and limbs when they proved distracting.

When J. Frederick Smith became a photographer in 1956, he brought years of classical art training and the sensibilities of a successful illustrator to bear on the subject of the nude. To the traditions of more than a century he would add a stamp of his own—the infusion of a delightful sense of feminine fantasy—that makes him one of the most successful practitioners of the craft working today.

This profile of one man's pursuit of fantasy and realism in the female form owes much of its strength to his friends and associates. Notable among them are Helen Latham, Bob Elwell and Jo Ahern Segal. Models too numerous to mention have shared their views from the other side of Smith's lens. Generous assistance has been given by Geza Verik, Chris Baldwin, Erla Frank Zwingle, and of course, J. Frederick Smith.

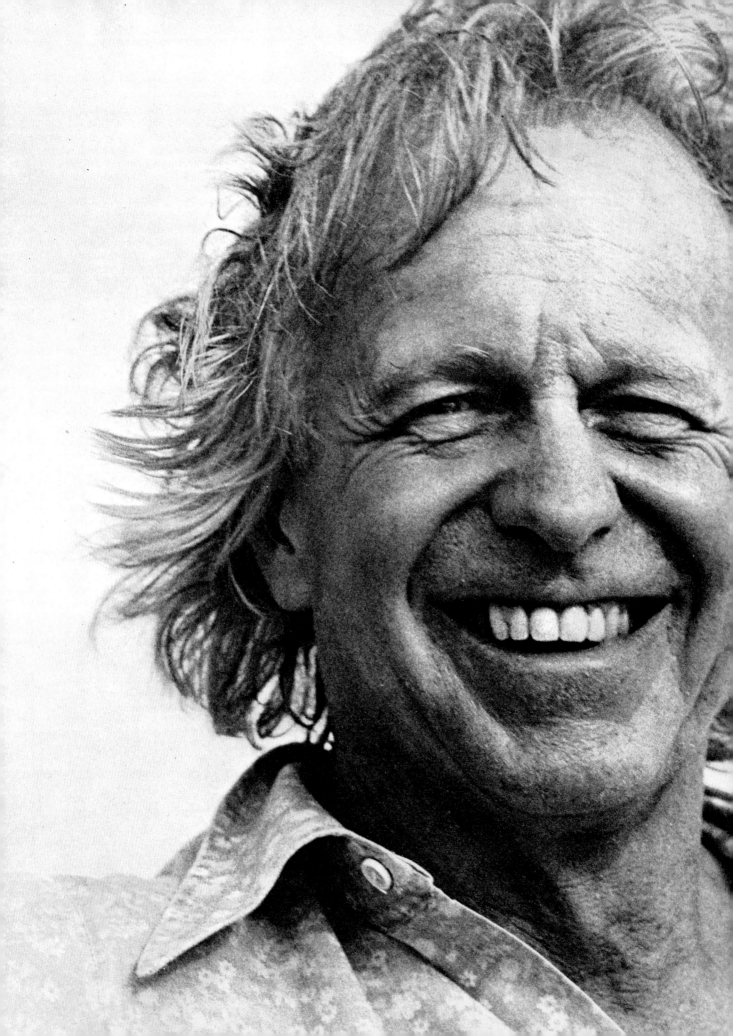

Pursuing sensuality with brush and camera

Midtown Manhattan below Herald Square and Murray Hill and north of Greenwich Village is a plethora of drab old factory warehouses, loft buildings and railroad tenements. Weekdays, its cobbled cross streets are clogged with trucks jockeying for vacant loading platforms and a driver who finds none often discharges his freight right in the street or heaps it high on the sidewalks. Through this labyrinth of clutter pass some of the most eye-catching women in the city. They are models, wending their way through the mire of exhaust fumes, packing crates and girl-oglers. In this unlikely setting most of the nation's leading advertising and fashion photographers have lo-

cated their studios. Lured by the hope of being "discovered" for a cover, or more likely finding some catalog work to tide them over, they make their daily rounds of the photographers ("go-sees" is their expression) to smile warmly, to say or do something that will cause a photographer to remember them, to leave a composite, and then trudge on to the next stop.

Sooner or later their agencies will tell them to go see J. Frederick Smith. They will ride a shaky elevator up the 12 floors of an office building, pass through a litho shop where acrid chemical smells fill the air, climb a winding, narrow, dark set of stairs and arrive at the haven of his

penthouse studio. Some never want to leave.

Smith bounds out to meet them. He is of medium height, with charming, elfin features, white hair almost to his shoulders, a coquet grin, radiant eyes that practically twinkle, and a slender body, trim but for a bewitching little pot belly.

For such an accomplished photographer his studio isn't the slick photo factory one would expect, where every strobehead and lens cap has its proper place marked by a plastic Dymo label. The studio is old (it was once the hideaway for the roguish 19th century architect Stanford White). In fact, it's a bit run-down. A visitor who arrives just after a Smith shooting session would swear that he has just walked in on the aftermath of a teen-age slumber party. Strewn about are old clothes, pillows, veils, chiffons, cut-off Levi's, shoes, hats and a few telltale bottles of wine. Hardly the signs of a successful photographer—yet that's his secret. Smith creates a deceptively simple lived-in environment that allows every woman to retreat into her own private reverie to play, to

A Smith trademark: raggedy but revealing clothes.

frolic with abandon, to doff her inhibitions as well as her clothes while Smith is in the background, subtly coaxing her ever onward and quietly capturing her sensuality.

The pursuit of sensuality began when Smith was very young. His earliest childhood recollections are of wanting to be a painter, and when the other kids in Pasadena, California, were playing cowboys, John Frederick Smith was playing artist.

"I guess you can say I had my first exposure to young ladies at the age of three," Smith recalls fondly. "My mother liked to remind me of the time she caught me making a portrait of a little girl who lived next door. She found us out in the courtyard, and I had

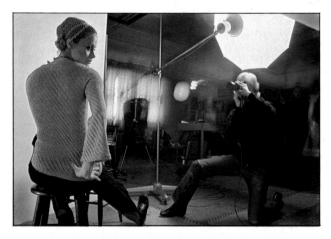

15

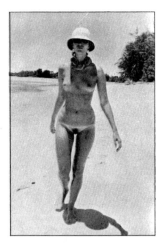

A model (above) strolls the beach for Smith. Below, Smith with son Sean, an aspiring photographer himself.

somehow convinced my playmate to take all her clothes off.'' They were mildly reprimanded, and young John Frederick was encouraged to investigate other subjects —like locomotives.

When he was five and an only child, his parents moved to Covina, California. Although only 20 miles east of Los Angeles, Covina in the Twenties was still very much in the country and surrounded by citrus groves. He built his first studio by rigging a hammock up in an old avocado tree. There, he was able to pursue his anatomy lessons with the help of Sears, Roebuck catalogs. He would copy the corset ads and then draw the figures without clothes. The nearest neighbor had a little girl Fred's age whose big love affair was with horses. He would gladly play cowboys with her for a while if she would later play artist with him. Again, his parents found them nude in an orange grove, young Fred happily sketching away. Smith eventually took piano lessons for 12 years, but his father, a successful businessman with banking and real estate interests, perhaps hoped that his son would occupy his chair as the president of the local bank. But by the time he was 14, Fred was firmly convinced that he wanted to be an artist. His decision was irreversible after he came across a movie magazine with an ad for a correspondence art school. The illustration showed an artist sitting at his easel surrounded by beautiful women. A high school field trip to his first museum gave legitimacy to his dreams.

In high school he **took to wearing his hair a bit longer than was the custom then, thereby acquiring the name "Rubinoff," after the violinist.** Being smaller than the rest of his classmates and not particularly athletic, Smith won their respect by painting racy nudes on their hotrods. It was even rumored around the campus that Rubinoff was getting some of the best-looking girls in school to go off into the orange groves between classes and pose

nude for him.

After graduation he enrolled at Chouinard Art School in Los Angeles, and the next year won a scholarship competition sponsored by the Walt Disney Studios, who were interested in developing good draftsmen for their full-length animated feature films. During a semester break he got an assignment from Disney to sketch jitterbug dancers in black dance halls. He hopped a bus for New York, and upon arriving he headed uptown for the Savoy Ballroom. Jazz was then, as it still is today, a smoldering passion with Smith. He hung out in the 52nd Street clubs, and when they closed he'd meander up to Harlem to linger in the after-hours nightspots until dawn.

During the Chouinard years Smith painted in a kind of romantic-realist style, probably influenced by the visits of guest instructors Diego

Rivera and David Alfaro Siqueiros. He would go down to Main Street in Los Angeles where the gin mills and flophouses were and sketch prostitutes and strippers.

''I didn't then, and don't to this day like prettiness for prettiness' sake,'' Smith says by way of explanation. ''All that leads to is the designing of another candy box. All the textures, shapes, compositions that I saw while hanging around the honky-tonk bars and in the burlesque theatres were a part of the other side of life that gave me a better grasp of reality.''

The siren song of New York called him back. Its singer was Billie Holiday, whom he had met on his first trip to the city. After graduation he moved to New York and took a flat in Greenwich Village. Downstairs lived Lady Day and Lena Horne.

''Billie was playing Café Society then,'' he recalls. ''I'd go to work

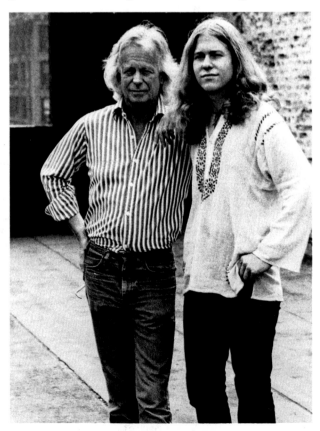

with her. She'd sing and I'd sketch and afterwards we'd meet Lena and go up to Harlem where they'd sing in the after-hours clubs."

He became a downtown Bohemian, shooting uptown nightly to get on the "whirling cabaret" that poet Langston Hughes called Jazzonia —where "night-dark girls of the swaying hips" danced till dawn.

"I was a frustrated jazz musician anyway," Smith says in retrospect. "After 12 years of piano I still couldn't play anything I couldn't read. I didn't realize how bad I was until one day I was talking to Joe Bushkin, a fine trumpeter back then. He was complaining about being broke all the time and saying that the only musicians making any money were piano players, so he was thinking about changing instruments. The next time I saw him, about six months later, he was playing piano in a club. I sort of forgot about being a musician after that."

Smith's heady introduction to New York nightlife provided the material for his first commercial portfolio. Art directors were receptive, but little work was forthcoming. When his money had all but run out Smith decided to take his first job, as an usher. He scanned the papers to check out what theatres were offering up the best jazz. Gene Krupa was coming to the Palace for an extended engagement, so Smith went uptown to be fitted for a uniform. Returning to his flat in the Village that night, he found a message from an art director with an offer to paint an ad for Elizabeth Arden. He took it, of course—it paid $300 —and quit his ushering job even before

An early Smith photo made for reference and his finished drawing for Collier's.

he had started. Never again would he have to sneak into a concert through the employees' entrance.

He fast became one of the hottest young illustrators in New York, grossing $70,000 in his first year, and over the next 15 years had an income that never dipped below six figures.

Smith had arrived on the scene when the illustrator was king. Photography was used sparingly in magazines. Aside from *Life* and *Look,* the hundreds of other periodicals on the newsstands relied heavily on illustration. Nearly all the advertising work went to painters and draftsmen. Ironically, most of their pictures were drawn from photographs expressly made for the illustrator to work from.

The greatest cabal of illustrators worked out of a co-operative organized by Charles Cooper. The Cooper Studio provided space for up to 40 top illustrators whose work was hustled up and down Madison Avenue by a staff of salesmen. The salesmen worked on commission, the artists split with the studio, and everyone got very rich. Smith joined this exclusive fraternity, but before he could reap many of the benefits, World War II intervened and for a while the only thing Smith was drawing was $80 a month. Then came a period when the Army put Smith's illustrative talents to good use painting orange groves on airport runways for camouflage and bosomy girls on engine nacelles for morale. While on a three-day pass he married Sheilah Beckett, a sculptor and illustrator, started up a family (two boys, Ian and Sean) and would soon have a sumptuous home in Westchester County, thus permanently putting behind him the romantic image of the starving Greenwich Village artist.

Upon his discharge he rejoined Cooper and, in the next 10 years, would become one of the country's preeminent magazine illustrators, specializing in editorial work for *Collier's, The Saturday Evening Post,* and *Esquire.* Looking back on it today, Smith wonders how he and his colleagues survived not just the staggering workload but the concomitant revelry.

"It was one great escapade. Sometimes we were churning out an illustration a day, but come four o'clock somebody would find an excuse to open a bottle of Scotch and then it would start. There was one 10x12-foot storage room filled to the ceiling with just White Label. We were located on the 24th floor and frequently someone would decide to take a walk along the ledge. Cooper himself was a prodigious drinker, and although a small man, after a few drinks he'd decide that he wanted to fight, so one of us would have to trade punches with him for a while.

"The sales staff was just as interesting. Cooper hired them not so much for their knowledge of art but for their salesmanship. One was from Wall Street, another had previously sold cement, and there was even an ex-cowboy actor.

"They would sponsor drinking contests that would start at Costello's, a bar across the street from our building on 44th Street, and the object was to have three drinks at every bar from there up to 57th Street and back again. The last guy standing was the winner. One night the designated drink was Suissesse, a lethal combination of anisette and Pernod. I didn't last very

long, but one guy eventually had to be taken to the hospital with a bleeding ulcer. I caught up with them the next morning when the drink had been changed to a much more sensible brandy punch.''

Smith's graphic style was highly photographic. A magazine editor would suggest a situation from the text piece, and Smith would cast for character types to fill the parts. They would then be photographed on a set with the props Smith specified. He would copy the picture on his canvas from an 11x14 blow-up.

From the very beginning he made his own photographs with an old Rollei and the help of Cooper's staff photographer. Few illustrators were prepared to go that far, but Smith was an unequivocal stylist concerned not just with the model's expressions or attitudes, but with all the props and clothes and the staging of every detail in the painting. Once he even went so far as to find Diamond Jim Brady's shirtmaker and have the old man make him a shirt just like the one the famous bon vivant used to wear. Smith put it on a model posing in a set-up that depicted a scene in the

With a favorite model on vacation in the West Indies.

life of Brady that Smith was re-creating for *Esquire*. In the illustration's final form, the authentic Brady shirt was mostly obscured by the showgirl sitting on the model's lap. No matter. If all this illustrates the excesses of the medium, it also shows Smith's concern with the entire tapestry of his canvas. Every thread was chosen with great care and meticulously woven into the final fabric of his pictures.

He became a favorite of *Esquire*'s brilliantly flamboyant editor, Dave Smart (who shortened his byline to ''J. Frederick Smith''). As a regular contributor, Smith illustrated fantasy stories on everything from the life of Lola Montez to the Ice Follies—all of them abundantly populated by suggestive gamines. At first Smith was given the freedom to interpret these stories in his own style, which by then had become very loose and impressionistic. But gradually the editors demanded that Smith tighten up his renderings and be more draftsman-like.

''Once they set me up in a studio at the Waldorf so I'd have the proper atmosphere to illustrate what was then an erotic poem by Walter Benton called 'This Is My Beloved.' Smart brought Benton up to recite the poem so I could grasp the proper inflection and better understand the poet's intent. Halfway through the recitation I could see that Smart was getting restless. When the poet finally left, Smart said, 'Okay, forget the poetry. You know what we want—tits and ass.' That was my first inkling as to what this business was really about.''

Over the years he was forced to pare his sets

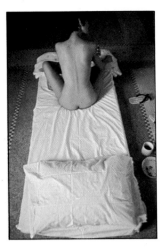

The tile floor pattern in his studio was one of Smith's ''found sets.''

down to a minimum and all the exquisite details he relished had to be sacrificed for hard-sell sex. *Esquire* was turning him into another Vargas-like pin-up merchant, so he gradually began turning down their assignments.

''It seemed I was drawing the same boy-girl clinches over and over. Art directors kept insisting that we get tighter and tighter in our compositions. It was a good living at $200,000 a year, but a boring life.''

A sense of ennui crept into his professional life and soon thereafter would affect his private life as well.

The solution to the professional problem had been in front of him all these years, tacked onto the drawing board in the form of an 11x14 print. He soon realized that his photographs were more interesting than his illustrations. They were the real end result of his creative energies and painting over them only diminished it. He decided to become a photographer.

Few people have entered the risky business of photography from such a financially secure position. With 15 well-paid years as an illustra-

tor behind him, Smith could afford the luxury of taking a year off to learn a new trade. His first step was to hire Cooper's staff photographer as his assistant. Then he began the arduous task of learning the fundamentals and assembling a portfolio of samples.

''I never realized what a physical business photography was. I had been sitting on my ass painting all these years. Now, after a day on my feet photographing, I was more tired than I'd ever been. That first year I was a mass of aches and pains.''

Smith's manner of working was enough to exhaust a seasoned professional. He adopted photography with the same kind of voltaic energy and wide-eyed enthusiasm that he felt years before when, as an art student in L.A., he first visited Main Street with his sketch pad. Even today he charges a set not just with his personality but with his physical presence too, flitting back and forth, never pausing too long on a picture before taking it. He seems thrilled by all the images that are constantly appearing on his ground glass, and he trips the shutter button to quench the tingle.

Alexander Liberman, art director of *Vogue*, had encouraged him to take up photography with a suggestion that he use a camera to do the kinds of sensual illustrations he'd been painting all along for the magazines. Yet the magazines, even *Vogue*, proved uninterested in Smith's brand of exquisitely styled photography.

But the advertising agencies were different. Smith's penchant for creating fantasy worlds became a very marketable asset, for fantasy is

the very bedrock of the advertising industry.

Smith's fantasy world is fed by a fertile imagination. He soon earned a reputation for producing a bewildering variety of pictures based on a simple premise, using just the barest of essentials. He was not only able but eager to take on a job, even if it didn't pay well, providing that it presented a challenge or, better yet, afforded an opportunity to learn something new about his craft. Some of his earliest fashion work was done for *American Weekly* magazine, the Sunday supplement of the Hearst newspaper chain. The magazine's audience was conservative and fairly middle-class, so the fashions were plain and simple. The Hearst pay was low, yet the work afforded him an opportunity for world-wide travel and the challenge of giving sophistication to something homely.

Smith's editor then was Helen Latham, who recalls, "He would take a $2.95 Vanity tricot and treat it as if it were a Balenciaga. He shoots extensively, exploring every possibility within the scope of the assignment and, when he's covered it to his satisfaction he stops, looks up and says, 'That's it.' And you know it is. He is not like a lot of photographers who shoot in hope that something will happen. He trusts his instincts and they usually are right. In all the years I've worked with him I never remember him ever having to do a re-shoot."

As with most low-budget operations, such expenses as airfare and hotels were provided free for "promotional consideration." Since there is rarely any story in fashion copy, this information had to be worked into

the pictures.

"The beauty of working with Fred," says Latham, "was that he'd come up with a sensational shot of a girl on the wing of an airliner and it wouldn't look like the obvious plug that it was." The sweep of her dress would mirror the line of the wing and somewhere in the background were those three little letters—TWA—that kept everybody happy.

Experimental shooting: A profitable habit

There are photographers who, after a modicum of success, make a conscious decision to become totally commercial. Their shutter-stomping index finger is for hire, and they won't lift a camera with it unless they are paid to. It's a rare individual who can afford this luxury, and

such an attitude can lead to complacency and lazy imagery. In the words of Elliott Erwitt, an unusual photographer who has been able to bridge the worlds of fine art and commercial photography, "You should be shooting all the time, even if you're not getting paid for it. Because in working, things begin to happen. Nothing happens when you sit at home." For Erwitt, advertising photography is the vehicle that allows him to take his personal pictures. And his personal pictures allow him to work out creative approaches that he brings to advertising photography. (See *The Private Experience,* Elliott Erwitt, in *The Masters of Contemporary Photography* series.)

Fred Smith shoots every day in his studio. It is his sketch pad. And whether he is testing a new model just off the street or photographing a friend's new pair of shoes, it all serves to sharpen his mind's eye and hone his working knowledge of the craft.

"If there is an interesting idea to be pursued," says Smith, "it's worth the risk to shoot it, regardless of the cost. At the very least it will serve to develop a better relationship with a client."

When stuck for a new idea, ad agencies frequently ask photographers to take on a vague concept for an "experimental" fee— usually enough to cover expenses—in the hope that a creative photographer will come up with the visual solution to their problem. The lure is the potential reward of getting the entire shoot-

A soft-focus effect for the Smirnoff campaign and, at left, a finished ad photographed without any special effects.

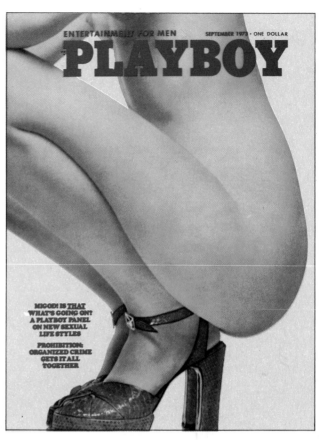

ing of a national campaign.

One of the great success stories in the annals of high-pressure marketing is that of Smirnoff vodka. It is a product totally made by advertising. Once an unpopular white liquor at the end of World War II, the product was promoted until it now outsells every other spirit consumed in this country. Smirnoff advertising significantly changed the drinking habits of two generations of Americans, and it required two different campaigns to do it.

The aim of the first was to develop an image of Smirnoff vodka as a sophisticated drink, which was accomplished in a long series of stylized ads designed by Hershel Bramson and photographed by Bert Stern. (See *The Photo Illustration,* Bert Stern, *Masters of Contemporary Photography.*) After vodka had established itself as a product, Smirnoff began to look for mass acceptance. Young people in the 1960's were not flocking to hard liquor, so Smirnoff decided it needed a new marketing plan. Bob Elwell, now a close friend of Smith, was the account executive from the agency assigned to find a vehicle. He gave Smith a chance at this advertising plum because he

A model's new pair of shoes inspired a test which eventually became a Playboy *cover.*

had been struck several years before by Smith's enthusiasm for a project that had also started as nothing more than an experimental shooting in search of an approach.

"For years, liquor advertising consisted of the bottle, the glass and the zingy line," Elwell says. "It was heavily product-oriented, and I wanted to find a way to make it more people-oriented. An emotional response was missing, so I went to Fred to discuss the idea of the drinking experience."

Smith cast around for a group of models who were bright, conservatively hip, and whom he could get to interact freely with each other. His plan was to have a picnic and cover it much as a photojournalist might, recording reality as it unfolded. On another level, he was going to take a bunch of kids out into a field, let them get a bit drunk, and see

what happened. Such a seemingly simple idea was daringly innovative for the industry, and fraught with problems—namely, controlling a bunch of free spirits when advertising photography is rigidly previsioned and tightly composed. The agency had the remarkable foresight to give him the freedom to shoot without a cadre of client representatives hovering about.

"Fred is not the kind of guy who should be directed," says Elwell. "Asking him to put the bottle in the lower left-hand corner of every picture would kill him. It would destroy the spontaneity in the picture, and in Fred, and would substantially reduce the credibility of the photograph."

Smith styled the whole shoot himself, from things he found in a thrift shop and other gadgets he found in an attic. He took two couples up to a friend's farm

tests were returned to him they came under the eye of *Playboy* Magazine's art director, Art Paul. He saw a cover, and quickly dummied one up. To comply with the magazine's tradition of having the bunny symbol somewhere in the picture, Paul had a retoucher put the emblem on the shoe buckle. Not bad for a test.

It was some time later when Bob Guccione, the editor-publisher of *Penthouse,* called with an assignment for *Viva,* the *Penthouse* sister publication run by Guccione's consort Kathy Keeton.

"Kathy got on the line, and said she wanted to do a shoe feature," Smith remembers. "It soon became obvious that something had been shot by somebody else and had been blown. They had to have something fast, but had no idea what. The test with the shoes came to mind, and I told them that I'd like to do a very graphic number. They said fine, they'd send the shoes down, and they wanted the film by the next afternoon."

Fred and his assistant hastily reconstructed the set from before. A large lightbox, covered with a heavy-duty clear plastic, was made for the models to stand on. A trapeze-like bar hung from the ceiling above as an aid to their balance. The shoes arrived. They were all size four. New York may have everything, but it doesn't have models with size four feet.

Up until now Smith's studio girl had been invaluable as she made appointments, kept his books and cooked tempting lunches for the clients and guests. She now assumed greater stature in his eyes when he realized that she had tiny feet. It was a magic moment when he slipped

a shoe on her foot and saw a perfect fit. The Cinderella from the back office became queen for a day, and with great good humor agreed to pose. Using Polaroid film, Smith tested the lighting and design concept. Overnight a petite actress friend was also dragooned into the shooting, and the next morning the girls gamboled across the light table, swinging gaily from the trapeze as Smith shot away.

"Fortunately the models were good friends," says Smith, "and didn't mind crawling all over each other. They thought it was a lark. The session lasted four hours. Some people might call that overshooting, but I was caught up in the momentum of the thing. None of us got tired. One picture inspired another and it just kept on rolling. I can never understand how some photographers can go to their set-up, take a picture and walk away. Photography is a lot more exciting than that."

The film was delivered to the magazine in time, and ran for 5 pages. Had Smith been able to use the traditional leggy models, the pictures would not have been nearly as successful. *Viva* markets sex as well as shoes, and the shorter, compact leg brings sex closer. A longer leg would have had less spice while presenting the art director with an unwieldy graphic that limits his choice of designs for the page. Smith provided *Viva* with a variety of tightly composed full-bodied structures that gave the designer free rein. He in turn rewarded the photographer by giving the story more space in the magazine than an ordinary shoe feature might warrant.

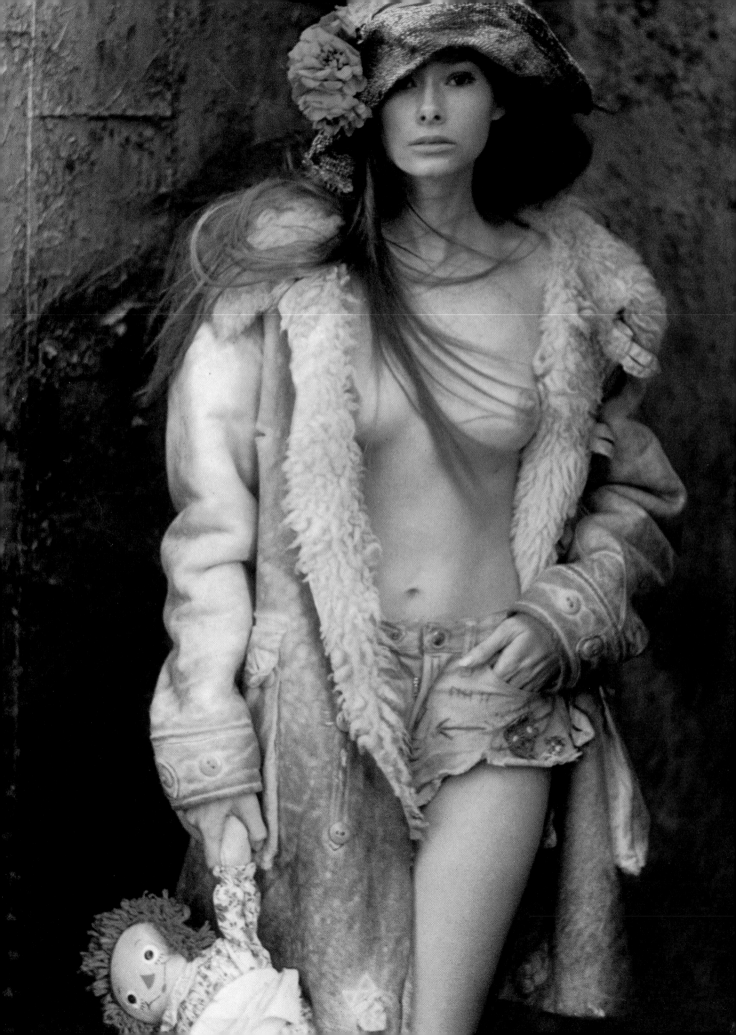

Creating an atmosphere for intimacy

Among photographers the photojournalists are romanticized, the fashion photographers glamorized, and the girl photographers patronized. Perhaps it is because of a secret envy that outsiders rarely offer up a good word for photographers like Smith. The photographers themselves don't even have a good word to describe what they do. "Girlie photographer" makes Smith cringe. "Girl photographer" is barely palatable. "Pin-up" is archaic, "tits and ass" is vulgar. There are few professions subject to so much myth, mendacity, rumor and rancor.

What is it that you do, Smith, and do so well, a visitor is asking.

Smith lies back, gets ensconced in the folds of his easy chair, and takes a long, thoughtful look into the crackling fireplace. He is in his Spanish-style penthouse apartment in Murray Hill on the other side of town from the studio, away from the din and clutter, away from the tension and excitement of a 10-hour shooting day.

Using the elements to create a different sensuality: indirect light on a cool fall day in New York (left) versus bright backlighting on a warm tropical day in Bermuda (right).

Sharing this duplex is an attractive 22-year-old international fashion model who has been the subject of some of his best pictures these past four years. She glides into the room, lays down a tray of cheeses and a bottle of wine and then disappears.

"I'm a chronicler of women. I see them my way, and have no apologies, no regrets. I'm not interested in photographing people in the street where you find them. I'd much rather bring them up to the studio and let them play with the things we have there. I'm intrigued by watching them play out their fantasy roles—and everybody has some of that in them—and I enjoy bringing it out and photographing it. I'm not a social reformer, I've never had any desire to be, but what I do put down in pictures has a certain integrity of its own, and that I'm proud of. Mine is a form of reportage like Degas' or Lautrec's that makes a comment on one phase of our society.

"Women are very much influenced by the fashion of the times. It affects not just how they dress but their lives and lifestyles. I'm not terribly interested in what's fashionable *per se,* but I use it in my work to help me interpret their femininity. I never let the clothes overtake the woman, and that's probably why I never work for the high-fashion books like *Vogue* or *Bazaar,* where the woman becomes a mannequin. My women dominate their clothes. The clothes are a device that brings them out of themselves. I have a raggedy work shirt that I've been using for years now.

Each girl who puts it on gives it her own special touch. For all practical purposes, technically, these pictures are the same. But they never look the same. I can go back through my pictures from 10 years ago and show you not only how they dressed, but also how they behaved, and it is totally different from how women act today."

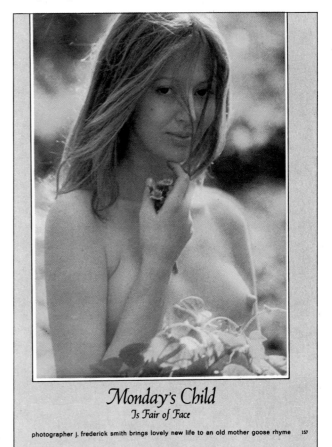

Monday's Child
Is Fair of Face

photographer j. frederick smith brings lovely new life to an old mother goose rhyme 157

Smith's photographs are erotic but never carnal. He maintains a level of taste by incorporating just enough fantasy to take the hard edge off. "Fred eschews the factually cold, at times hideous, look that many of these girls would have if photographed by a lesser photographer," says Helen Latham. "What keeps the photographs on this side of the fine line of pornography is that he is always able to keep the illusion going." Adds Jo Segal, former fashion editor of *Look,* "Fred's pictures are naughty, but nice."

The *oeuvre* of Smith runs from corny cheesecake to tingling erotica, from *Playboy* to *Penthouse,* from sensitive to sorrowful. The course of this versatility is not so much a desire to adapt to the demands of the market as it is a response to the temperament of the model.

"Fred imposes less on a girl than most photographers," says Bob El-

well. "If she is a chippie, then that's the way she is going to look, only amplified by his camera eye. If she is a waif, then that's what he'll make her." When *Playboy* suggested that he do a group of pictures illustrating the verse "Monday's Child," it was a simple task for him to dip into his personality file and cast the characters from many of the girls he had tested.

"I prefer to do my own styling on these things," says Smith. "It is very hard to find someone who can read your mind and then go out and find those things that match ideas floating inside your head. Lynn (actress Lynn Lowery on pages 26 and 29) has a naturally sad-looking face which, to me, seemed to fit the line 'full of woe.' She is a very feeling person, so all I had to do was have her put on that oversize sheepskin coat of mine and take her up on the roof of the studio where there is a little alcove that is always full of soft, indirect light. It was cold. The wind was blowing, which is an element I always like to have. Cold, hot, rain or whatever, it all serves to

A memorable Smith essay for Playboy *resulted from careful casting of models to fit the roles in the story.*

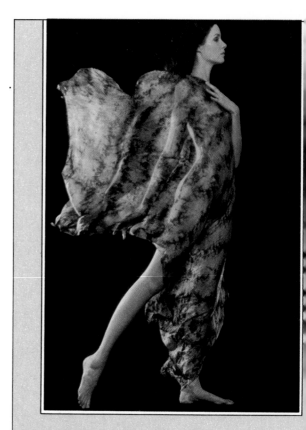

158 *Tuesday's Child Is Full of Grace*

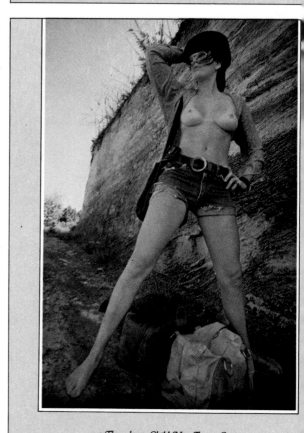

160 *Thursday's Child Has Far to Go*

28

Wednesday's Child Is Full of Woe 159

Friday's Child Is Loving and Giving 161

create something extra. The model has to react, even if it's to complain. If I had had to do the shot in the studio, I would have had a fan going and splashed her with water or oils or anything to get her to react to a sensation. When her senses are aroused she will project sensuality, and that's what we're photographing here.''

The line ''Tuesday's child is full of grace'' conjured up the image of a lissome dancer. Smith recalled how well Chris Palmer, a statuesque six-foot fashion model, had moved when he had shot her for an advertisement some years previous. Palmer and her agency were at first reluctant to pose for *Playboy* and set a $500-an-hour fee. Smith convinced her that his idea would be done in good taste and then convinced *Playboy* that she was worth the price. Remembering the shape that a billowing chiffon had given a model during a previous test (page 1), Smith re-created the effect with Chris Palmer. When she enacted dance postures, a fan blowing at right angles to the camera whipped the fabric into languid eddies that mirrored her motion (pages 28 and 31).

One would think that a man who wholeheartedly indulges in fantasy in his professional life would have difficulty adjusting to the reality of life outside the protective bubble of his studio. Yet in real life Smith is not the rakehell that one would expect from a man who undresses beautiful women with his camera every day. He lives a quiet life, dressing casually but comfortably in soft, muted colors. But that was not always the case. In his early days as a top-paid illustrator he lived the part of Jay Gatsby in the city, with fast cars, the best food, and expensive clothes. (He'd spend $300 on custom-made boots, and then more to have the buckles chemically treated to give them a patina of age.) But then at night he would go back home to the suburbs of Westchester; the duality began to erode his private life.

''I realized that I had left the city for the suburbs much too soon. Photography proved to be an even more demanding mistress than painting. I was spending more and more time in town. My hours grew longer, yet I relished the time spent here in the city. The interaction of its people was tremendously stimulating and it inspired me to work longer and harder. Sheilah

and I were growing apart, so we agreed to a trial separation. I moved into a hotel intending to stay two weeks, and ended up staying a year.'' After 25 years of marriage, they were divorced.

Smith acknowledges that he leads a great fantasy life, but he is quick to point out that it is one that he has actively sought out, something that he works at daily. So, he asks rhetorically, how can a fantasy remain a fantasy when you make it real? It's really not such an imaginary way of life. It can be reduced to such basics as having good models, having concern for them, and staying aware of the things around them.

Models are a most maligned lot. Their image stems from a society that rewards physical perfection and a human tendency to take the easy way out. As a result they are thought of as vain, selfish, stupid, temperamental, irresponsible, lazy, mercenary and self-destructive. They are. They are also exciting, alert, sensuous, spontaneous, imaginative, hilarious, energetic and beautiful.

Their flashes of mood are as irregular as sunspots, and when they burst into a room they disrupt communication and scorch saner minds and eyes. In order to photograph them effectively someone like Smith pulls back a bit, views them through a filter of reasonable thickness, and analyzes where they're coming from.

''The lay person has a very narrow idea of what it is to be a model,'' says Smith. ''They think of it as a questionable profession, glamorous but superficial. As far as I'm concerned the great models that I have worked with would have been outstanding in any other profession—be it medicine, law, theater, anything—had they chosen that instead of modeling.''

Of course, the most popular belief is that there is a lot of hanky-panky with the photographers. To a degree this is true, and because it has happened before it makes it difficult for all photographers and models to work together.

''When a girl first decides to go into this business it is natural that she think that she is walking into a den of iniquity. But if you can convince her that she is not going to be chased around the room, she will relax and enjoy herself.

''A model by definition is an exhibitionist. She wants to perform. It is up to you to give her a comfortable stage on which to perform, and without any of the old taboos lurking in the wings. Every girl who comes into my studio is to me a potentially interesting person that I'd like to explore with my camera. I try to create an atmosphere, an environment, that will make her feel that it is her home for the day.''

What seem like devices in the studio, such as the ever-flowing wine, the snacks and the good music in the background, which Smith changes to suit the temperament of the model, are really no different from what he serves up in his own home.

After a wearying day in the studio, where he constructed five sets to shoot eight different advertising pictures, Smith sinks deeper into his chair. He is finally coming off the shooting high. In the darkened living room his face disappears and the visitor follows his conversation by watching the catch light from the fireplace dance in his eyes. They haven't slowed any.

''You have to treat every girl as if you were taking her into your own home for cocktails and dinner. And if a seduction follows later, fine, but don't force it. It's a delicate process of building her self-confidence. Good models aren't just in your studio to pick up their $65 an hour and split. They want to make good pictures too.''

Smith inspires trust with a gentle demeanor. He is a gentleman at a time when that word denotes little more than gender. The word hasn't dropped completely out of the vernacular. His model friends always use the word ''gentle'' when talking about Smith. In conversation he is apt to describe his models as ''ladies.''

He has a loyalty that goes beyond the studio and the time when they are in flower. For some, the studio is a haven, a comfortable bubble away from the racket of the street below. He encourages that, partly as a way of keeping in touch with the outside world. For those who retire and move on, there are occasional phone calls and letters. Elwell recalls that once when they were in California doing a Smirnoff shooting, the need arose for a special living room set. ''Fred just went into his little black

Saturday's Child Has to Work for Its Living

book and made a phone call to a lady in the area who had just what we needed. It turned out that this housewife was a model he had known 15 years ago, and with whom he had always been in touch." One of his "ladies," to whom he refers as "my all-time great beauty," married and settled down 20 years ago. Smith is now photographing her 18-year-old daughter.

"Fred is a man of another age," says Helen Latham admiringly. "He

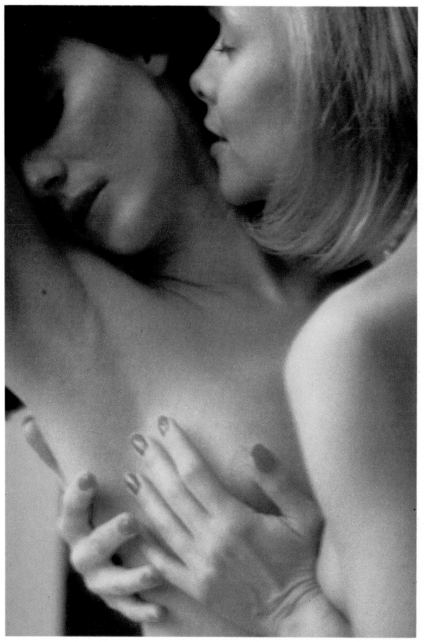

really knows how to relate to those women. He can find something exquisitely marvelous about every one of them. If he has a fault, it is that he is enthralled with all their little problems without ever being really objective about it. Many of his relationships are with Pygmalion figures. There are a lot of girls in this town who would be nowhere if it weren't for him and his pictures. He is naturally youthful, and where most men his age would look foolish sur-rounded by all those young things, on Fred it looks good.''

After all these years of exploring women's sensuality with a heterosexual viewpoint, Smith has begun investigating a woman's homosexual feelings—what he calls ''the essence of womanhood.'' He claims to be both puzzled and fascinated by it, and quite probably this will be the

Smith's first published book will contain illustrations for the poems of Sappho.

most important personal project he has yet set for himself. Two years in preparation, it may take even longer before it is ready for publication as his first book. The book's premise is an illustration of the lyric poems of Sappho, the ancient Greek poetess. She wrote of love with a remarkably natural simplicity, and although only fragments survive, it is popularly thought that because Sappho lived in exile on Lesbos her verse was directed to-ward homosexual love. Smith's photographs show homosexual love both in actuality and by implication. But much of it is suggestive of sensations other than physical love that are shared by women. Critics may point out that the work is invalid because Smith is neither female nor homosexual. Regardless of its success on that level, the pictures demonstrate his ability to elicit intensely intimate behavior from models who are practically strangers to

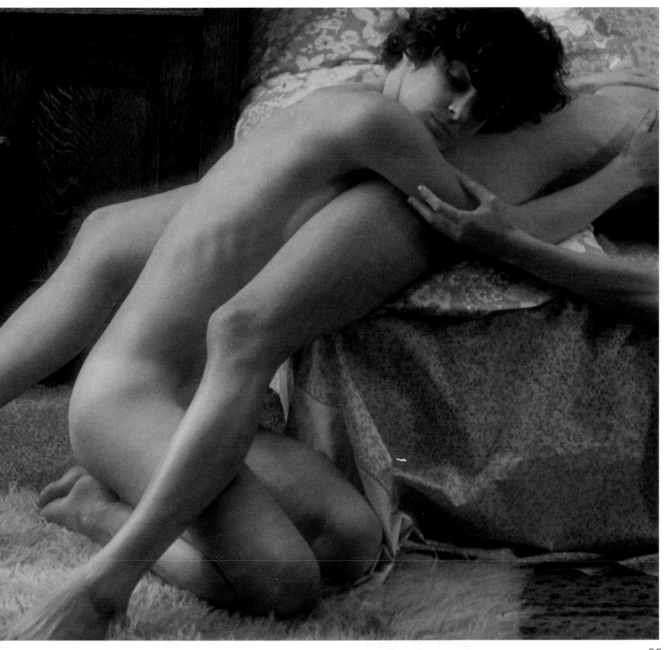

each other before he throws them together while Smith himself remains unobtrusively in the background.

"Watching these sessions unfold," he says, "has broadened my outlook on women. It's been a lot like analysis, both for me and the models. They have been given a chance to play out fantasies they never dared imagine. Some are overt, some are remote. Others are tender or wild. I put them in a real environment (as opposed to a constructed set) and let it happen."

Mention the word "pinup" to Smith and he pulls up short. To him it connotes a feeling of heavy-handed styling designed to tantalize. What separated *Playboy* from

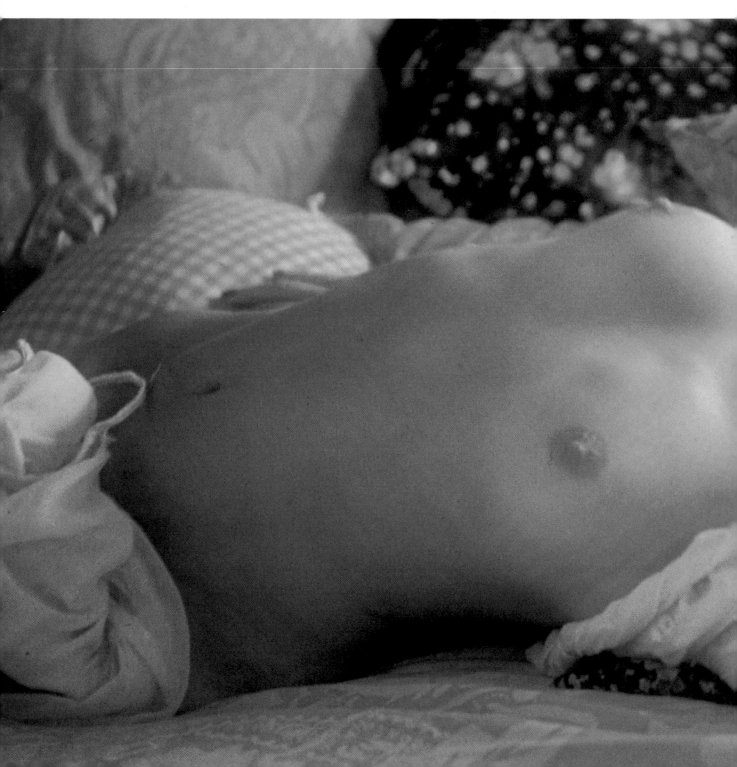

the pulp men's magazines in the 1950's was an effort to be relatively subtle about marketing sex. Hugh Hefner's editors attempted to portray a woman in a somewhat naturalistic environment, even if it was unnatural for her to be naked, perfectly made-up, gracefully composed and evenly lit for the cameraman. There was an eye contact that suggested that the model was as approachable as the girl next door. She didn't convey the aloofness of a professional showgirl from downtown. The best photographers working this genre began to approach ''girl photography'' much like

A Playboy *test of Swedish actress Agneta Eckmeyr.*

photojournalists, trying to capture her real personality as it unfolded in front of them. In actuality most of the home bedroom scenes were constructed in a studio, but they were done with such careful attention to detail that they seemed authentic.

It all starts with the right choice of models. Smith prefers a girl with an average figure (bust size is relatively unimportant to him, but he'd rather see it smaller than bigger) and few preconceptions about her physical beauty. ''A girl who is uninhibited about her body and looks fresh and sparkling is always more sexy than a *zaftig* woman just lying there. I prefer letting her run free.

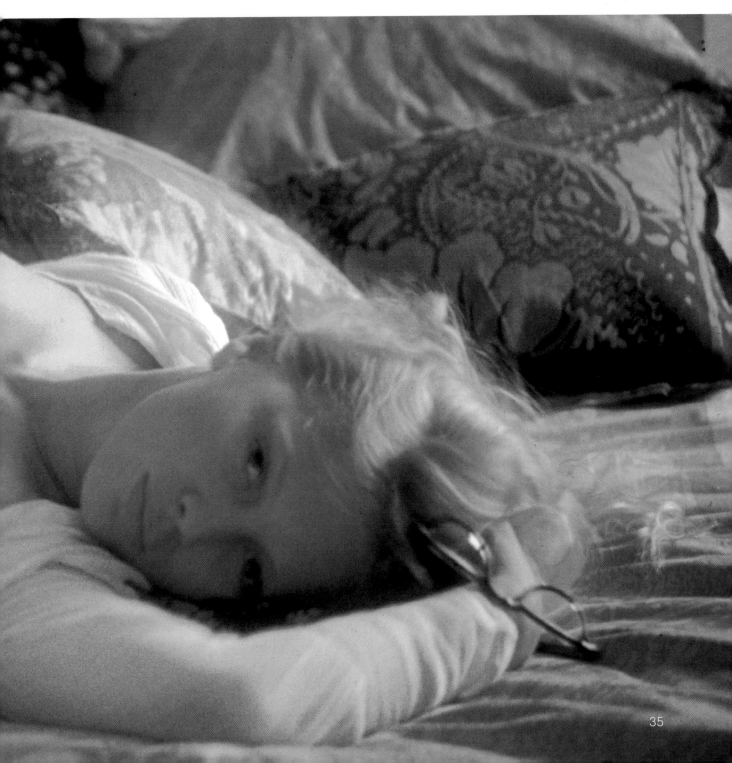

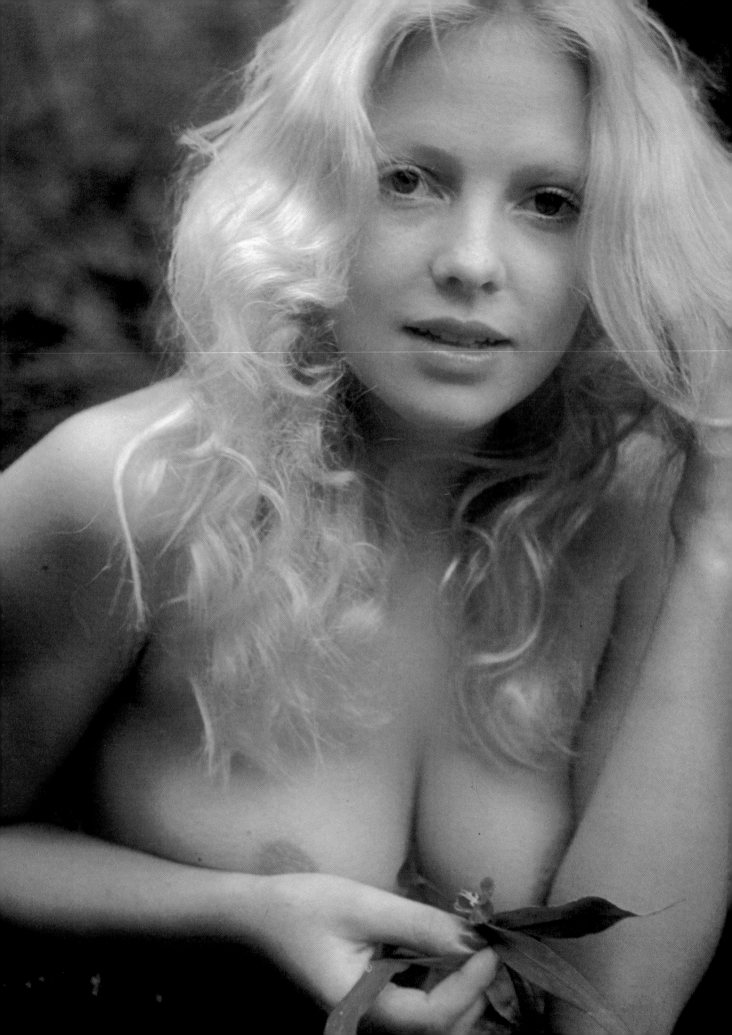

"Working with an unknown is exciting. I'd prefer a girl who has never considered herself sexy *Playboy* material. I know that with the right lighting and the right environment and the model's desire, we can do it."

And if he really had his druthers, Smith would opt for an actress, professionally or intuitively. Her ability to respond to his cues and take flights of fantasy are prime requisites for shooting a Playmate. One of his favorite models is a young Swedish actress, Agneta Eckmeyr, whom he met when *Playboy* assigned him her test shooting. With a minimum of equipment and a camera bag slung over his shoulder, he showed up at her Central Park West apartment one day. Over a cup of tea she talked of her interest in antiques, mentioning that the most valuable were in her bedroom. After seeing them Smith suggested that they begin right here, where she was most at home.

The first pictures were made on her bed (pages 8–9 and 34–35) at 1/8 second as the existing light filtered through the window creating a mottled, impressionistic pat-

Smith changed the pace without changing locales. Moving out to the terrace, shooting close and wide open, he obscured the city backdrop, making it seem as bucolic a scene as that taken months later in the country (at right).

tern across her body. Later (at left) they moved out to her terrace, where she toyed with some plants on the balcony.

Looking back on these pictures, Smith says, "I think Agneta quickly realized that whatever we did was going to be done in good taste. She wasn't a 'femme fatale' who was always postur-

ing and I wasn't about to make her one. We got along immediately. She is subtle, imaginative, and humorous, and that's what I look for in a good model. If a girl possesses those attributes you can do anything with her."

Later, Pan American Air Cargo would commission him to produce 12 pictures for a calen-

dar—a true pin-up—and Agneta posed for one shot. Smith was hampered by the restriction of not being able to show nipples or pubic hair. This always calls for deft placement of greenery and hands and arms. There are just so many places you can hide a nipple, so, after a morning's shooting for the client, Smith and Agneta

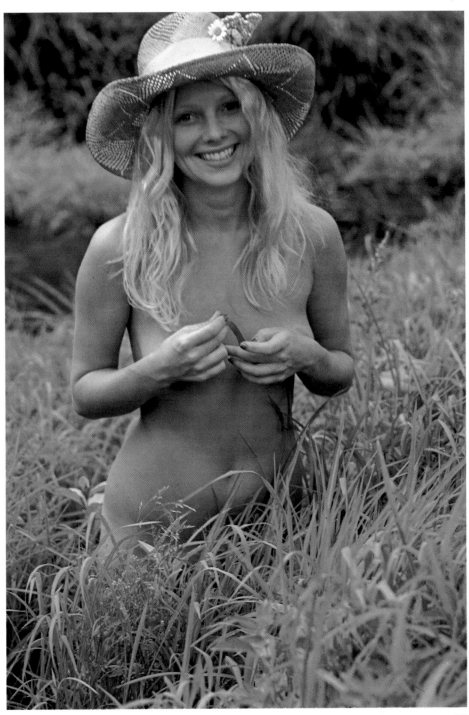

decided to make pictures
for themselves. From this
came a sequence
(below) of her running
down a country road
with a basket of wild-
flowers and playfully
challenging him.

It is Smith's habit to
take any assignment and
push it as far as it will
go. He will make it more
sensual, more erotic,
than the client can per-
mit, partly out of a per-
verse curiosity to see

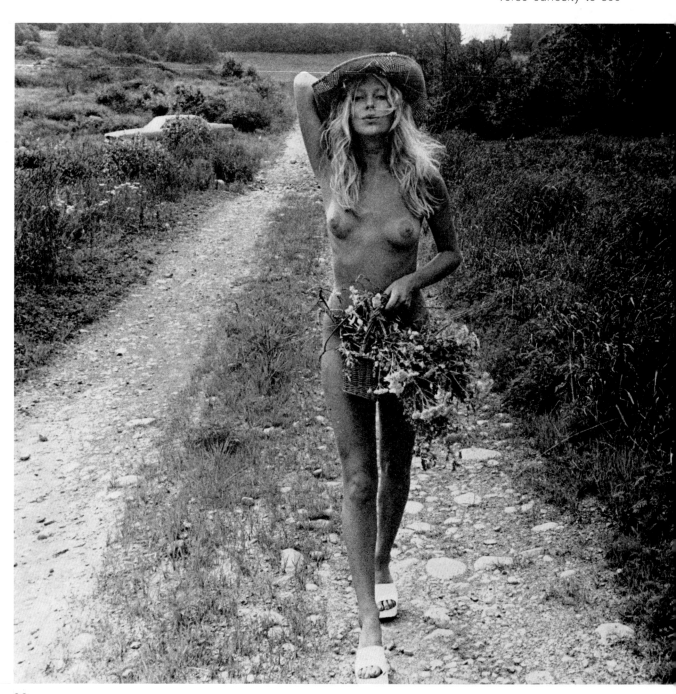

just how far these things will go. But also, on another level, he knows that these situations develop a momentum that he may never be able to recreate. He wisely gets it all down on film, knowing that he can always pull back in the editing process. Many times a client ends up with a more sensual—and successful—picture than he had envisioned. Pan Am found his wholesome nudes so appealing that they relaxed their standards. They also relaxed their security, and 20,000 of the calendars were stolen out of the warehouse, never to be found again.

Smith treadmilled with the model to create an animated sequence culminating (next page) in a surprise gesture that he was alert enough to capture with his wide angle.

One of Smith's stock devices to get life into his pictures is having his models walk toward and away from him. On page 16, a glaring tropical sun created cherubic patterns under the feet of his model that caught his fancy. Agneta's frolicsome air inspired another walk. To keep her in the frame he had to treadmill backwards. But Agneta gained on him, and in a spontaneously

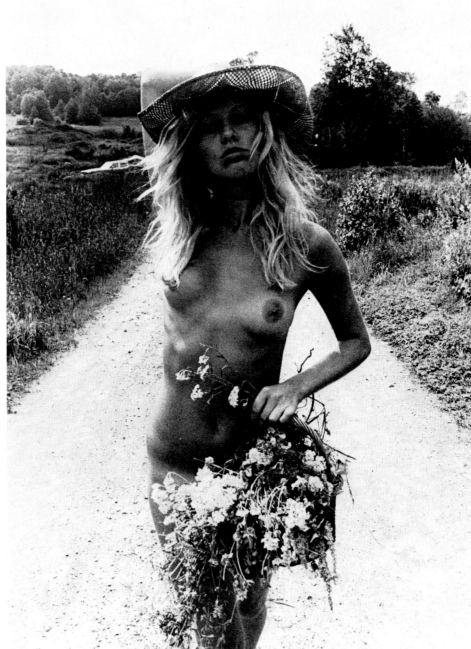

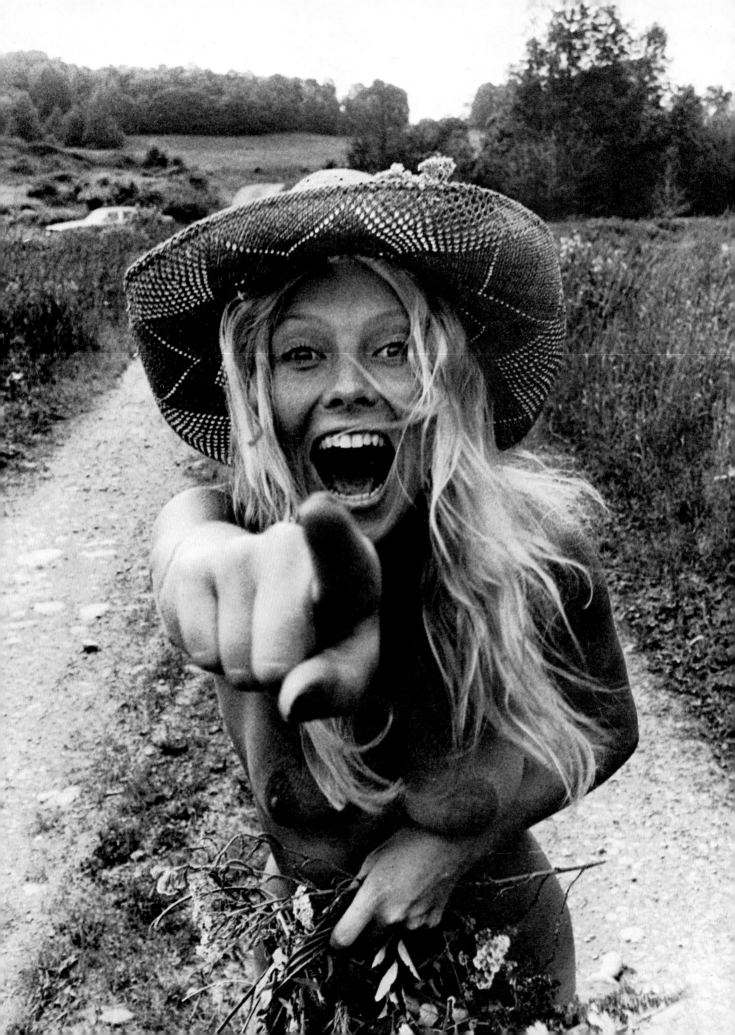

playful gesture (at left) stuck her finger in his lens. Smith had the presence to hold his position and get the picture, which, luckily, was in focus.

Art Kane, musing about the year he recently spent as design director at *Penthouse* and *Viva,* says he feels that in many respects he failed in his attempt to raise the artistic standards of such magazines because he lacked a sense of humor in his photography. "Guys like J. Fred Smith," Kane says, "are successful in this business because they can combine the erotic and the light-hearted at the same time. Fred knows how to introduce an element of whimsy. (See *The Persuasive Image,* Art Kane, *Masters of Contemporary Photography.*)

Sex magazines are, at their core, not an outlet for serious art. The slick veneer that conveys a fantasy notion of male-female relationships masks a very determined product designed solely for the marketing of sex. Photographers and editors who take a serious view of it will not only produce dull pictures and dull magazines, but probably go crazy from mental and physical self-abuse.

For the photog-**raphers, the temptation to sample all the flesh that presents itself can be the biggest obstacle to success.** Smith maintains rigid control over his private and professional lives—although he admits to having slipped on a few occasions. To counter the popular myth that photographers in his business lead great sex lives, he tells the sad tale of a former assistant:

"I once employed a guy who, it turned out, wanted nothing more in life than to fuck every model who came by. Well, he did and he didn't. The law of averages was in his favor because a lot of girls come through here in a year's time. But he was

A model's changing moods require different techniques. Here, a somber, reflective pose is modified by soft back light.

never able to get his pictures made or his portfolio put together. After a while the models in town got wise to him and he became the object of a lot of their jokes. He didn't do very well after that—either personally or professionally.

"If you choose to become involved with every model who takes her clothes off for you, you'll soon come to an impasse. You can't work anymore, and you won't be allowed to."

Smith is sensitive to the notion that photographers are lechers at heart, so he will go to

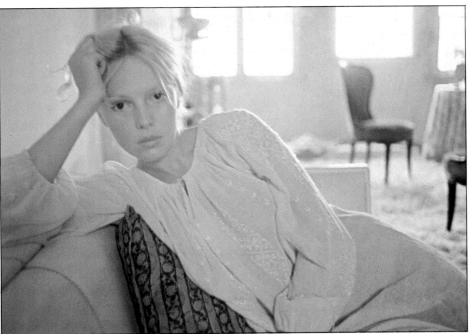

A picnic with a friend is an excuse for pictures.

awkward lengths to avoid touching a model on the set. The situation is always exciting, but Smith's participation in the act is limited to verbal caresses. It often comes as a shock to a new model when, at the end of a particularly erotic session, Smith turns and walks away.

"You have to learn to love a girl for the duration of the job. It's really the best of all possible worlds for the photographer. Basically, it's a masturbatory exercise for the model. It has to be built up slowly. In such sessions I work her slowly into the mood, never pushing too hard at first. You give her a chance to explore what she is all about. It's narcissistic, self-indulgent, true, but it's a great turn-on for them. It builds up just like lovemaking. There is foreplay, the act itself, an exhilarating climax, and that marvelous depletion and blissful let-down. Many models have said that such sessions are more exciting than pure sex, largely, I assume, because they are not only experiencing it, but are helping to direct it. They put themselves exactly where they want to be. And when it's over,

there are no awkward or emotional exits for either of you."

There is an apocryphal story that floats around the offices of Magnum, the photographers' cooperative, about the time Henri Cartier-Bresson, one of the founding fathers, encountered photographer René Burri at a train station. The two men hadn't seen each other for some while, and embraced in the lobby. Henri quickly frisked his friend. His first words were, "Where's your camera?"

Dedicated photographers of all stripes carry cameras at all times. Smith is no exception. A picnic in the country is an excuse for a session. An actress friend suggested the trip, and Smith turned the afternoon into a theatrical exercise for her and a documentary for himself.

"This becomes a marvelous way to communicate with someone. Some sessions are al-

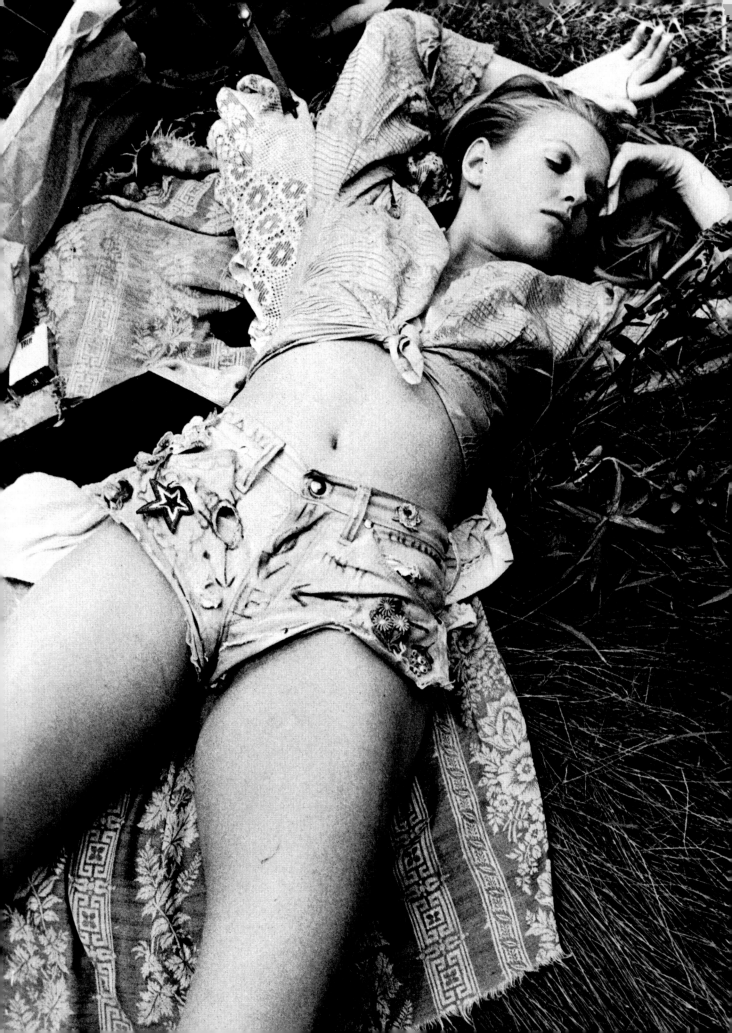

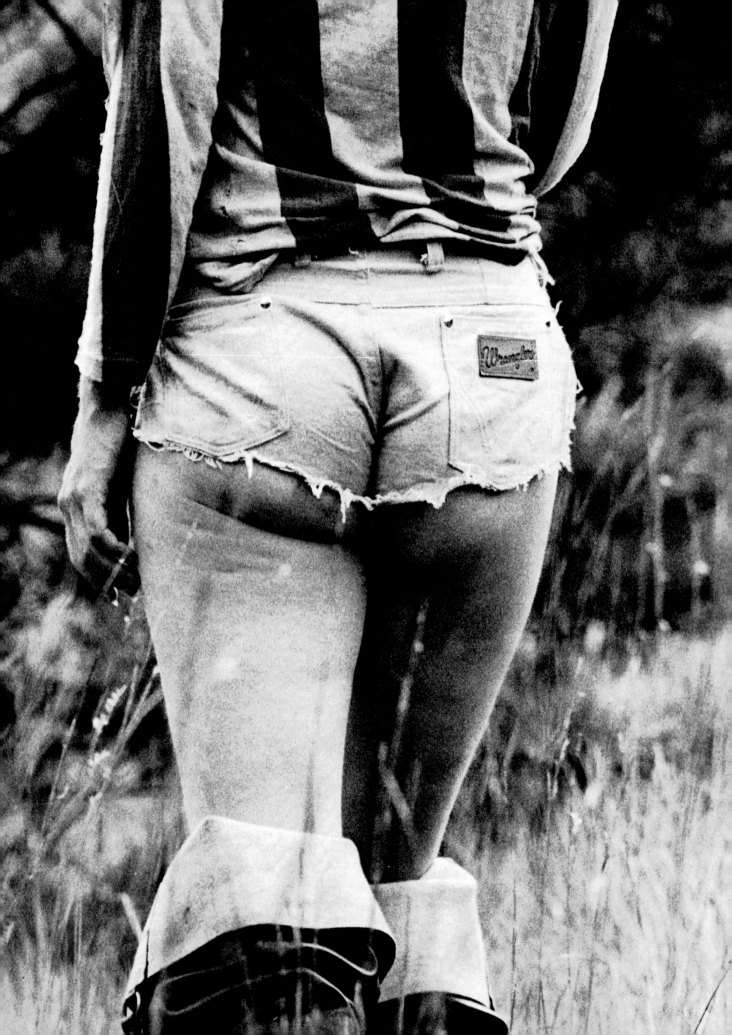

most like group analysis. It is you and her, and the camera becomes the vehicle that brings it all together. You find yourself saying how beautiful or fantastic she is and really meaning it. It would seem awkward to say these things without the camera there, but the instrument becomes an entity of its own and legitimizes the event. I become excited by what I see, and she becomes excited because I am.''

Like any other session it employs subtle direction and certain stock situations. He brings her to a stream so she can get involved in water. There is good food and drink. And a languid peeling off of her clothes to bathe in the sun. The clothes are always outrageously incongruous, shattering the typical image of a wood nymph. They are a

Novel props and clothes can break the formality of a session.

new experience for the model, too, who is forced to view herself with a totally new perspective that draws her attention away from the camera's presence and more to herself, producing a more intimate, candid portrait. Smith even goes so far as to load her up with bags and send her romping through an obstacle course, over logs, through streams, up cliffs. The exercise puts even more distance between the subject and the director, as she has to concentrate harder on her immediate problem and not the problem of making pictures for him. It also produces some delightfully comic moments.

Smith travels light, usually with two cameras and three lenses (55mm micro, 105mm telephoto, and on occasion a 35mm wide-angle). He refuses to talk of the mechanics of the medium with his subject. (''It's like discussing the kind of contraceptive you use before making love.'') And he keeps the action flowing even while he's changing film, so as not to disrupt the mood. ''If I had my choice,'' says Smith, ''I'd use natural light exclusively. Nothing can equal that, plus a good day of shooting.''

Fashion: Using locations

Yet not all of Smith's pictures are made in natural light, any more than all of his subjects are devastatingly beautiful models. He eschews classic perfection in a woman, preferring instead to work around the chinks in her beauty that give her character and a style of her own. One of Manhattan's most celebrated models, Samantha Jones, had a brilliant 10-year career while sporting a nose like Streisand's. Lauren Hutton, nationally known for her Revlon ads, has an eye that is slightly smaller than the other, the crest of her lips don't match, and there is a gap between her two front teeth which she plugs with a specially designed cap before smiling for Richard Avedon. But once in front of the camera, good mod-

els trigger a spark that inspires the best from their photographers.

"Flawless beauty really bores me," says Smith. "All great faces have a slight imperfection. I like a slightly crooked nose or a bit of overbite. But what I really go for is a raucous, whimsical humor in a woman who has no preconceptions about her body. I derive the greatest satisfaction from shooting that kind of girl, especially when she sees the pictures later and can't believe it's her. You see, I'm not really interested in taking photographs. Merely shooting pretty girls, and fixing the image on film is no fun for me. I like to *make* pictures. You spot something in the character—be it an attitude or an expression—and you make a picture of it. Suddenly you have a whole new way of looking at womankind."

Model Maralenko (pages 6, 7, 46–49) can hardly be called a classic face, yet she is a successful model and one of Smith's favorite subjects. Slender to the point of being nearly transparent, she has a vivacity and ebullience that can turn a photo session into a marathon. Once she

A marathon testing session with an energetic model and a grab bag full of props.

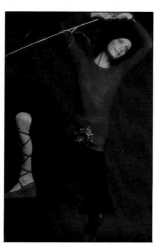

and Smith shot for 14 straight hours with a grab bag of props that she brought back from the Paris flea market. She dumped them all on the floor of his studio and then began to improvise a series of skits that Smith recorded until the early morning hours.

Once he made a set of pictures of a brilliant actress who always thought of herself as being quite unattractive because she didn't have a good figure. Consequently she always played tough roles. At first she resisted the idea, but one day she relented and agreed to a session. Smith had a set built in the studio and approached it as if she were in a play, giving her situations to act out. He put her in a bed, got her up, had her bathe and dress. Slowly she began to loosen up and began to fantasize. He coaxed her on, shooting at her best angles and making sure to use the most

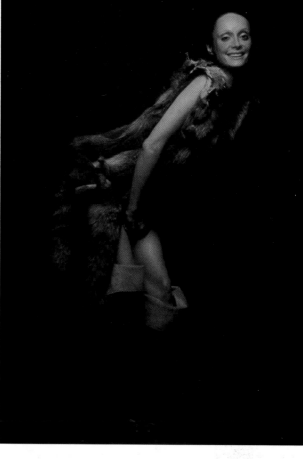

flattering lighting.

"Later, when she saw the pictures, she just couldn't believe it was her. I convinced her that it was, and that there wasn't any retouching, and felt quite good about the whole project until about a year later. One day she re-appeared in the studio and said that she had had difficulty accepting the person in the photographs as herself. She had looked in the mirror, and, in the harsh light of her own bathroom, saw a nose that was different from the one in the pictures, so she went to a plastic surgeon and had it made over. She later went back to have her jaw trimmed, and then her cheekbones. Apparently this gave her confidence, because her career skyrocketed, but I felt a bit sad. All that had happened during the session

that day was that she had relaxed and projected herself into a role that she previously felt she couldn't play.

"I've done nude sets with women of 55, and they have been just as successful. By providing the woman with the proper environment and creating a mood, you can take them away from their present image of themselves. It's a great escape for them, and a greater challenge for the photographer."

Although photographing girls in the studio is Smith's avocation, it is supported by fashion and advertising assignments. He approaches his fashion work from another direction. Nearly everything he shoots is done outside the studio. He refuses to shoot against seamless paper, abhorring the slick sterility of it.

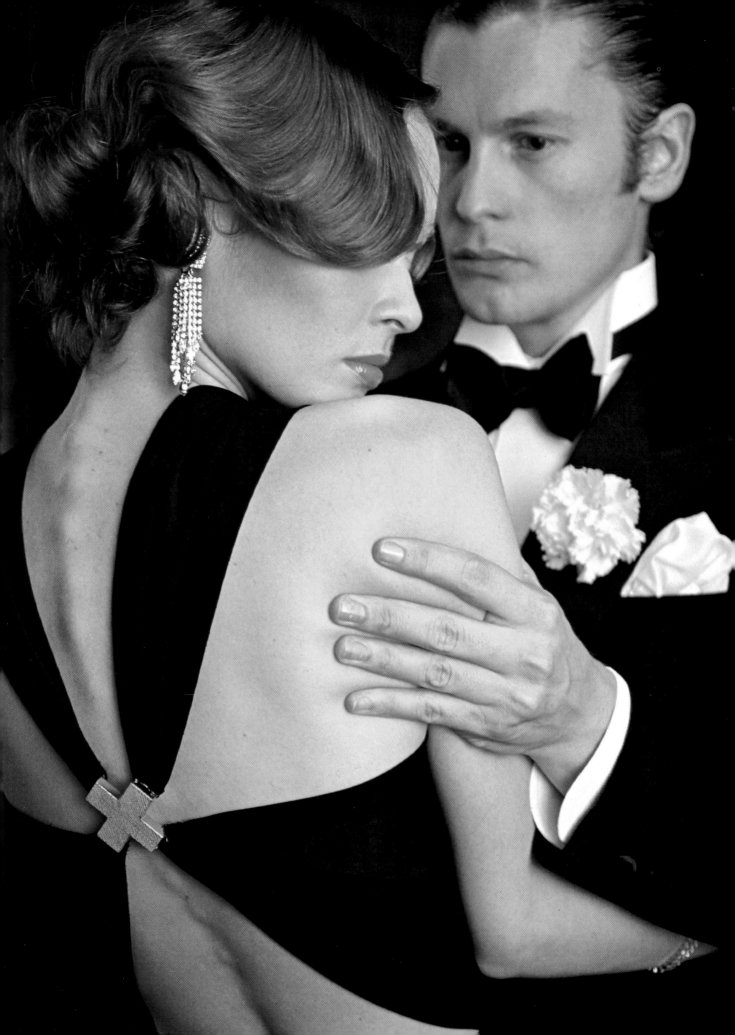

"Shooting fashion on location, where everything is new and fresh,** is always more exciting than working on it at home in your studio. There are certain limitations placed on you by the clothes you have to show, so in the studio

For a Look *fashion story on the clothes from the movie* The Damned, *Smith worked with its star, Helmut Berger. A patina of decadence was carried over from the picture by cross lighting the set with colored fill lights.*

you might begin lapsing into stock poses and reverting to standard devices that you have on hand. On location, the change in the environment causes you to use tables, chairs, drapes and landscape in such a way that you could never preconceive or duplicate."

Call it confidence or cockiness, but Smith always walks onto a location cold. He trusts the judgment of the magazine's editors and stylists to provide him with the basic tools of light and color. He rises to the challenge of unforeseen problems, dares to commit himself to their solution, and shoots with confidence in his own instincts. Smith's preparation for a major *Look* essay on the clothes from "The Damned," the 1969 movie by Luchino Visconti about the decay

of Berlin society in the Thirties, consisted of seeing the film the night before. The picture would have an effect on fashion, adding impetus to the lowering of hemlines throughout the industry. Fashion editor Jo Segal wanted the story to look both romantic and sexy, and shot in posh locales about the city. She had actor Helmut Berger fly in from Europe with his movie wardrobe, and Smith recreated some of the scenes from the film with models she provided. To suggest the decadence of the movie's theme, yet not to cloud the elegance of the fashions, Smith put colored gels on the strobeheads used as fill lights, which gave a touch of theatricality to the production. He admits that working with colored strobes amounts to some guesswork.

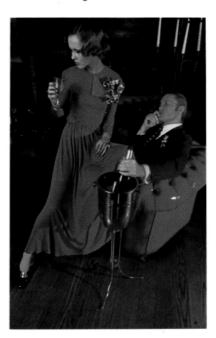

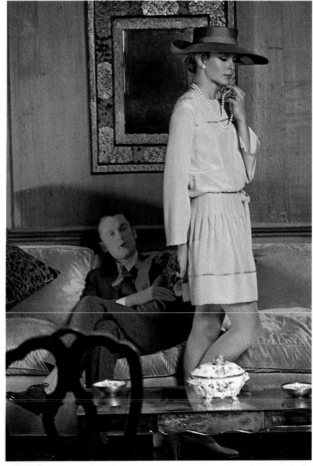

"With color sidelights you get only a vague indication of how the final result will look. But if I had worked out the concept in the studio ahead of time, there would have been a meticulous concern on my part to keep the models within the technical limits of the shot. The pictures would have become stiff. You have to do a lot of praying and compensating the other way, but winging it works."

When **Helen Gurley Brown was still Helen Gurley, she was a regular reader of** *Esquire* and a fan of the illustrations of J. Frederick Smith. "I thought that they were just DELICIOUS," she says, "and I used to cut them out of the magazine." Later, as the innovative editor of *Cosmopolitan,* she would employ Smith to help her change a withering magazine with a fragmented readership into a phenomenal publishing success that captured a large share of the single female audience. Speaking of the magazine's photography, *Cosmopolitan*'s art director, Linda Cox, notes that "whatever it is that is identifiably *Cosmopolitan,* is there in part because of Fred's ideas." Adds her editor, "Fred obviously loves

Smith imparts sensuality in fashion by highlighting the model's garment in the foreground while her lover waits in the shadows.

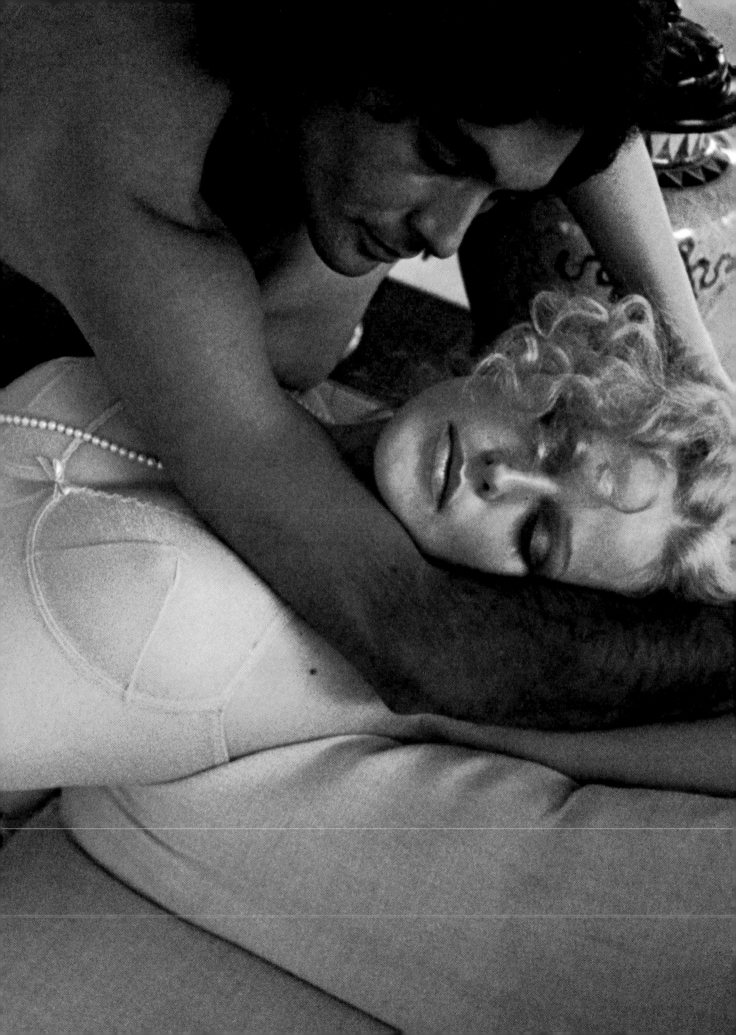

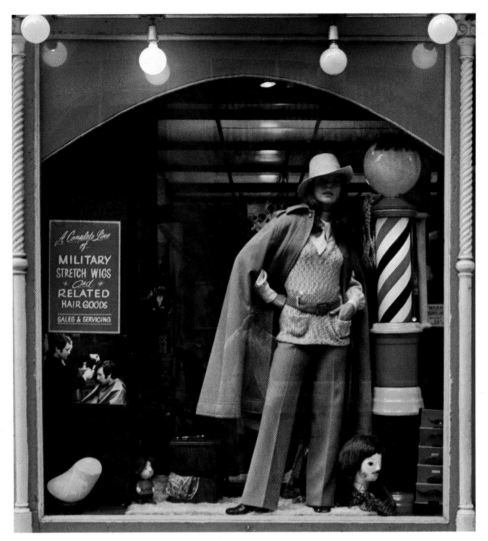

on location, that's it for you and your ideas. They do it their way, regardless. I think that's a bit of a cop-out. After all, you are a commercial photographer when you get right down to it. It's harder to do it Fred's way by shooting to satisfy the client. One of the unique things about Fred is that he respects other people's ideas."

The *McCall's* story, entitled "Window Shopping," put models in storefront windows around Manhattan—a play on department-store window mannequins. But with an added fillip. Smith used a variety of store backgrounds, some as incongruous as the barbershop at left.

Working with models in fashion requires a different mentality, a different approach. Usually there is a group of editors, art directors, stylists and assistants standing around. Distractions abound. Behavior patterns emerge. Gone is the intimate one-on-one relationship that Smith covets.

"Models can be a real pain," says Bob Elwell, who has worked on several group shots with Smith. "If one creates a unique piece of action such as twinking her nose in a certain way, and is applauded for it by the photographer, then all the others in the shoot start doing it. Happens everygoddam time.

women because there is a very heterosexual feeling to his photographs. He respects the man-woman relationship. His is not the view of a chauvinist male. The women in his pictures have a sexual identity that seems to be more their own than something he has applied to them. He is one of the few photographers out there who can interpret what we are trying to say, and that is that you can be very sexy and very sensual and yet still be sensible."

Smith can adapt to the sensibilities of a magazine like *McCall's,* too. "Shooting for *McCall's* is much more lady-like," he says. "They place much more emphasis on fash-

ion *per se,* so the models tend to be mannequins. They affect certain stock poses and never have to do any emoting. The magazine is very secure in this approach, and quite successful, so there's no use trying to change it."

"Fred's extremely accommodating," says Jo

Using models as manne-quins in a McCall's *fashion story.*

Segal. "Tell him what you want, and he'll work very hard to give it to you. Some photographers will listen quietly when you explain what you want, nod politely, and then when you get

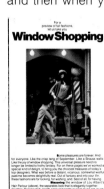

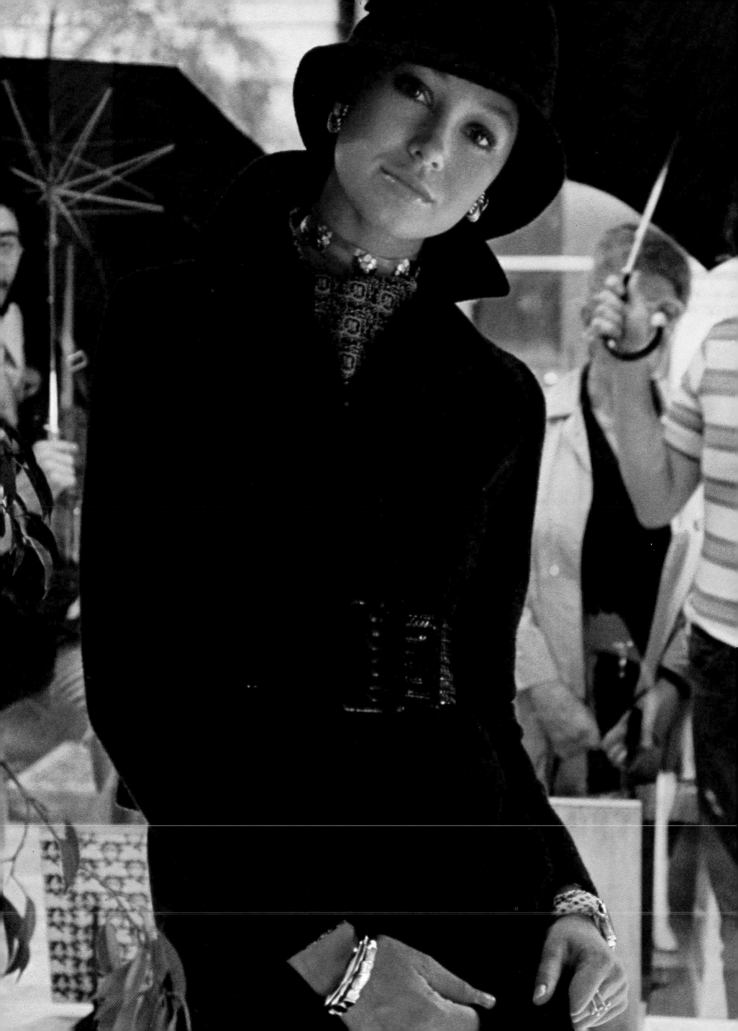

Fred picks up on this very quickly, and heads off chain reactions. He will go to another girl to suggest something different, and then to another to get her started on something else.

"Like most photographers, when he works alone with a girl he is making love to her with his camera. In a group shot this atmosphere is not possible, so he sets up some kind of interaction between the principals to free them. They become too busy to concentrate on him photographing them, and the whole complicated scene becomes much more natural."

Smith adds, "Models are naturally turned on by the camera, and easily fantasize situations if you throw them the right cue. One has to direct them to keep them together. I may say something to one that is designed to affect the others. Each group of models will establish

its own society. You don't have to be so rigid as to define roles for each one of them. They evolve their own. A leader will always emerge within the group, so you control the others, either directly or indirectly, by playing others off that leader. Sometimes there will be one who freezes up, spoiling your shot. You have to get the others to help him or her out. All of this draws attention away from the camera. It's just like conducting an awareness group."

For traditional fashion shootings, Smith prefers a good model over an actor. "Actors need lines and a suggestion of a plot in order to perform," he says. "Once they start it's difficult to stop them. Shooting for the more fashion-conscious magazines requires tighter discipline. Good models perform on a very narrow stage to an audience of one. They know how to play off a

design or work into the shapes and textures around them."

M

odels who have worked for a different type of photographer, such as **Pete Turner,** find him quite impersonal compared to Smith. Turner treats models as objects to be worked into his severely pre-conceived designs. Every square millimeter in his viewfinder is under his strict control. He knows precisely what he wants the girl to do, and when she falters he prevails by overwhelming her with his fierce determination.

Smith works the opposite corner. When he wants the model to change what she is doing, he never voices disapproval, but subtly re-directs her, tugging her in the direction he wants with encouraging phrases such as "Good, let's try it this way now," and "Fantastic, how would it look this way?" He keeps shooting, preferring to waste several exposures rather than break the mood.

"I'd much rather be the model on the shooting than the art director," says *Cosmopolitan's* Linda Cox. "Fred is verbally making love to her in just the nicest way. He can take the stiffest model and at the end of the first half hour she's his.

Some fashions have designs that lend themselves to startling graphics and should be allowed to dominate.

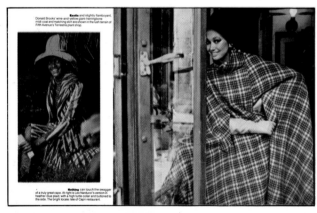

Exotic and slightly flamboyant, Donald Brooks' wine-and-yellow giant herringbone midi-coat and matching skirt are shown in the lush terrain of Fifth Avenue's Terrestris plant shop. **Nothing** can touch the swagger of a truly great cape. At right is Leo Narducci's version in heather-blue plaid, with a high turtle collar and buttoned to the side. The bright locale: Isle of Capri restaurant.

 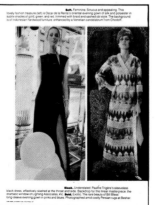

Soft. Feminine. Sinuous and appealing. This lovely fashion treasure (left) is Oscar de la Renta's oriental evening gown of silk and polyester in subtle shades of gold, green, and red, trimmed with braid and sashed obi style. The background is of Indonesian hardwood furniture, enhanced by a Venetian candelabrum from Chodoff. **Sleek.** Understated. Pauline Trigère's sleeveless black dress, effectively slashed at the throat and side. Backdrop for this linear masterpiece: the dramatic window of Lighting Associates, Inc. **Bold.** Exotic. The rare beauty of Bill Blass' long-sleeve evening gown in pinks and blues. Photographed amid costly Persian rugs at Besher.

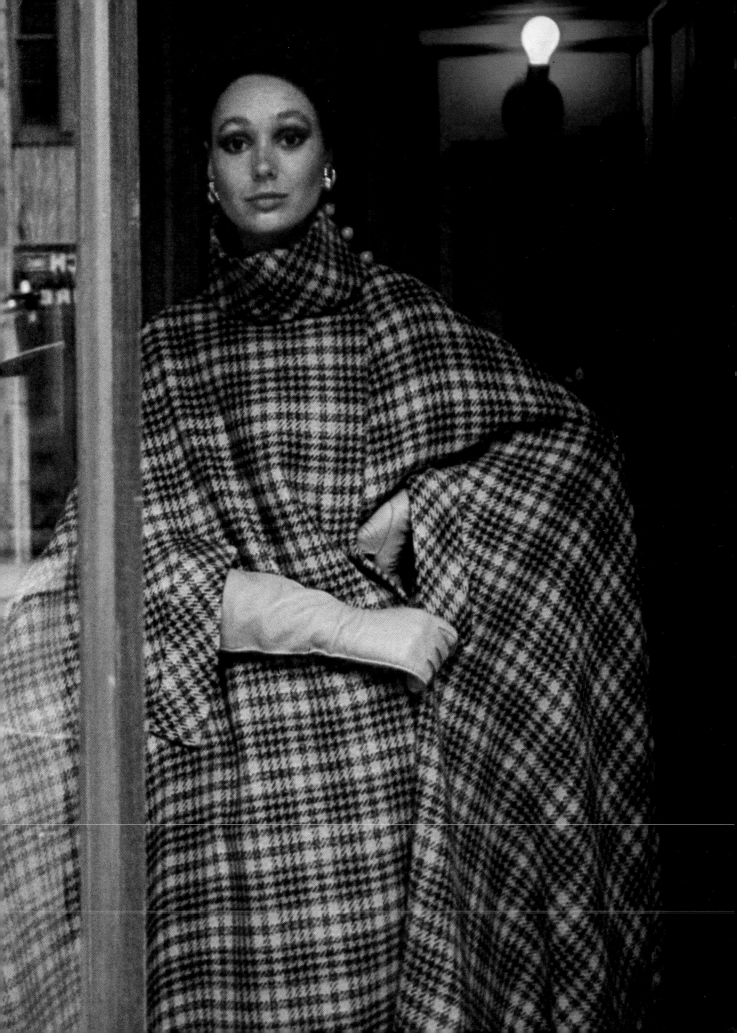

"We always discuss the story ahead of time to make sure we're operating on the same wavelength, but once he starts working I never suggest moving the girls one way or another. He is more interested in the girl than the clothes she's wearing. He doesn't fuss over whether the seams are straight, but concentrates on conveying the feeling of the moment. He is able to get something out of the model that is just incredible, and the last thing I'd do would be to interrupt it. Too many photographers are unable to elicit this kind of feeling from a girl, and often I end up directing the model and the photographer is just clicking pictures."

"Shooting fashion for *Cosmo* is enjoyable," Smith says, "because they couldn't care less how much product shows, which is nice. It allows you to concentrate on the emotional content of the picture. They are more up-front than most fashion magazines about merchandising. They always write up a big, bold caption full of buying information that keeps the manufacturers happy."

Every boy-girl picture at *Cosmo* implies an impending seduction. A photographer could shoot the same thing for *Bazaar* and would make the couple look blasé. But at *Cosmo* he has to make the reader feel that a romp in the hay is imminent. For a lingerie story (pages 52–53), Smith photographed the models on a living room couch. At first glance the situation seems ridiculously out of place. But on second thought the reader thinks that she might just have interrupted something.

In recent years *Cosmopolitan* discovered that a part of its audience was ready for sexual fantasy stories of the

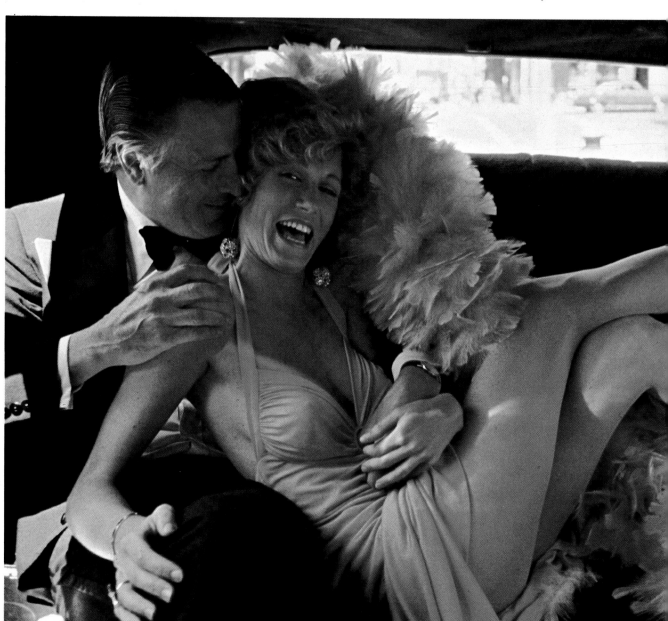

kind that had been running in the men's magazines. Growing up in Los Angeles, Helen Gurley Brown recognized that the car (hers was a Mercedes) was an important vehicle on the road to her sexual maturity, and rightly surmised that her readers shared some of the same experiences. She and Smith discussed their mutual fantasies and evolved a scenario

A fantasy story for Cosmopolitan *entitled "Love in a Car" had one girl with seven different lovers—two of them below.*

for a story in which one girl would be portrayed with seven different lovers, each of whom had a unique lifestyle as exemplified by an automobile. "I have to admit," says Brown, "that I'm not quite sure what we're doing in these stories. I think that some of the stories in *Viva*—some of which Fred has done —are quite beautiful. We don't go that far, they're gamier. But I thought that we could do our version that would be light-hearted and show how love in a car can be intimate but not

confining."

Smith chose a freewheeling model who was up for the lark of being shared by seven different men in two days. In a whirlwind shooting schedule around New York, he had her playing musical cars, jumping from a Maserati Bora (pages 4–5) to a Cadillac to a VW camper.

Smith's preoccupation with location shooting can border on mania. A costly *Cosmo* shooting of winter coats was scheduled for a remote corner of Long Island. When the cast assem-

bled on location, the entire Long Island Sound area was blanketed in a fog so thick that Smith's favored 105mm lens showed only an impenetrable wall of gray. He decided to shoot anyway. "I have a theory that rain and snow only help a picture. In this case the fog softened the image of what were terribly garish clothes to begin with. They looked to be designed for the Himalayas, and here we were shooting them at the seashore. I took the models up to a cliff to try to get a craggy back-

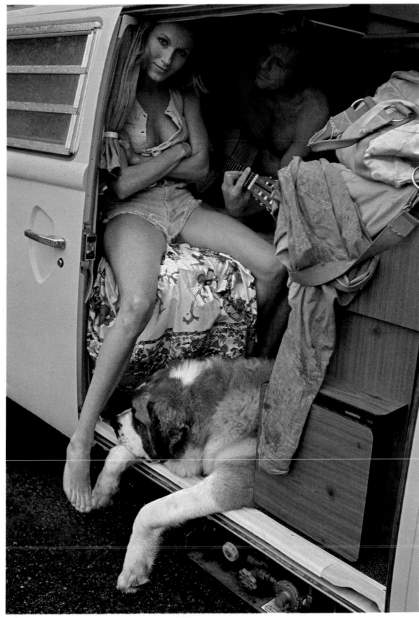

drop, and when the fog rolled in, it kind of suggested altitude'' (pages 60–63).

Going on location serves to charge the models as well as the photographer. Things become more relaxed. Location work is usually booked for a flat day rate that eliminates the pressure of the hourly clock ticking off the models' fees. Spirits rise and a different ambiance builds when total strangers are brought together in a new place for the first time.

Once, Smith arrived on location for a Breck ad to find the area being pelted by rain. The client representatives threw up their hands and prepared to return to the city. But Smith persevered. Perhaps out of morbid curiosity, the clients decided to stay on to watch this madman try to shoot a hair ad under sheets of rain. ''I got some clear plastic tarps to hold over the models' heads so I could shoot below and through them. The spirit

With fog so thick a tele-photo produced a cloudy image, Smith retreated to a wide-angle lens that gave drama to unusual outer-wear fashions for Cosmo-politan.

on the set became festive. The client representatives got into the act by holding the makeshift tent, and although they got soaked, they loved it. It kept them out of my hair, too. The rain acted as a marvelous diffuser on the forest in the background, and the overcast created a fantastic soft, even light.

''Over the past 18 years I've probably been weathered out maybe half a dozen times. If it is at all possible, I'd rather shoot. It's exciting, because it challenges your thinking, and it always manages to produce a different kind of picture.''

When the Breck people saw the photographs, they were ecstatic. They called to offer Smith another job, and wanted to know if he could guarantee rain.

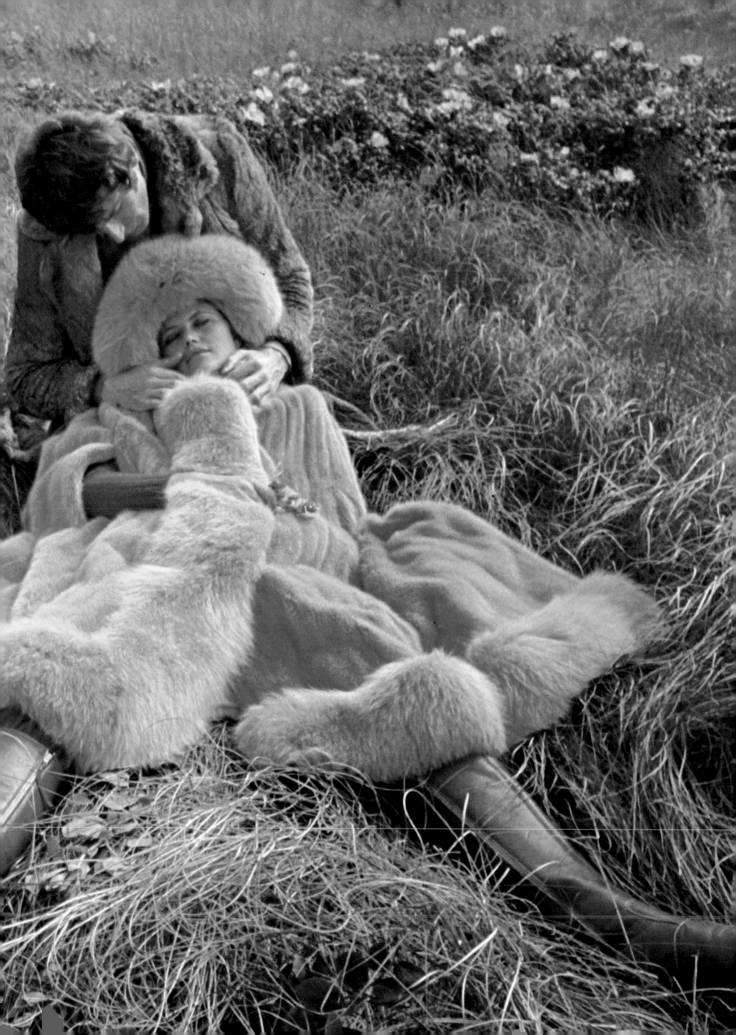

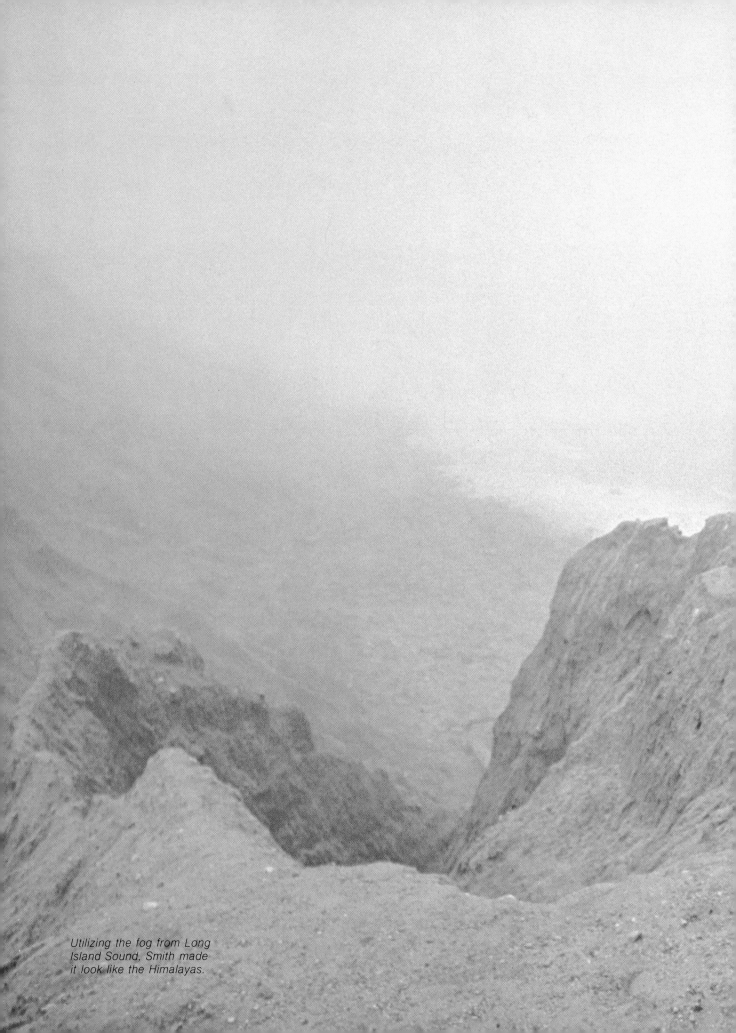

Utilizing the fog from Long Island Sound, Smith made it look like the Himalayas.

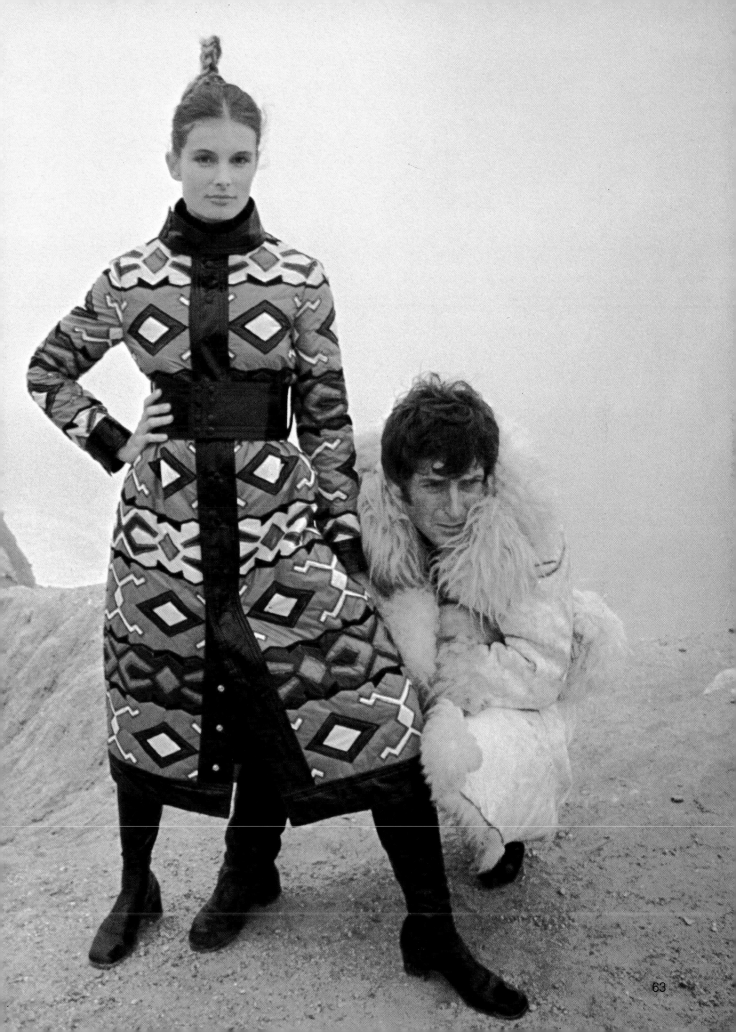

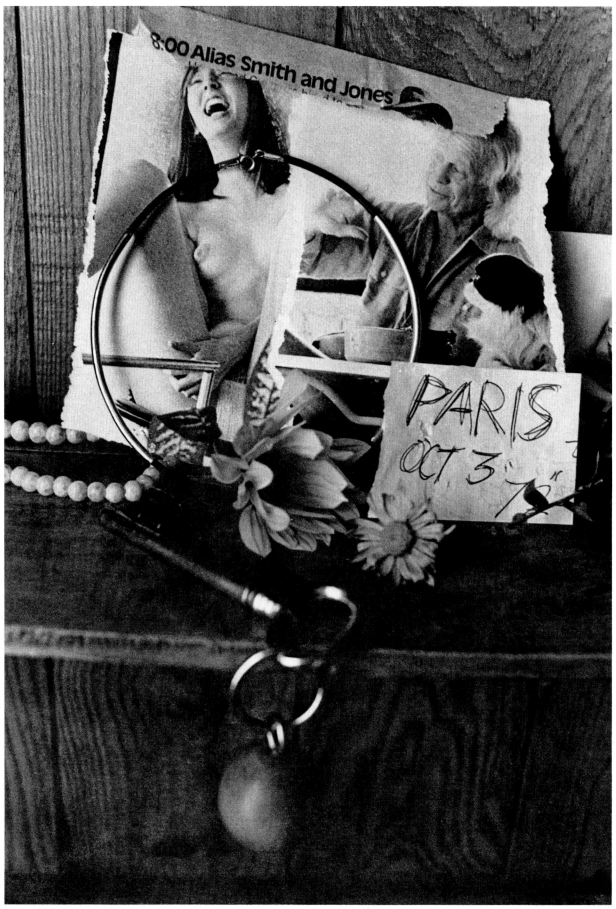

Personal documents: Photographing friends and lovers

"I still get a kick out of taking pictures," says Smith. "I shoot every day and come alive when I look through the viewfinder. If I'm kept from photographing I get fidgety and frustrated. Even on a day when I've done a big job I still look forward to the time when I can experiment with something. When you're consistently working in the framework of advertising, doing layouts, then very soon you're going to become warped. You need time to make your own personal pictures, and you're only as good as the work you do in experiment—that is what is going to keep those jobs coming in."

Some of Smith's best experimental work is in the form of personal documentaries he has made of friends and lovers, of trips taken in actuality or just in his head. Contained in hand-bound binders covered with a fine fabric and tied together with ribbon, like a folio of love letters, the pictures

are mounted back-to-back on a special textured printing paper. They are picture stories with a beginning, middle and end. Some are as personal as a weekend rendezvous in Paris with a girlfriend (at left and this page), others as sensitive as the study of a mother-daughter relationship (pages 89–96).

These pictures are more reportorial than commercial. They are candid, intimate views of the private world of a photographer. Gone are the lights and props and makeshift studio sets. Everything is a found object—the girl, the place,

the time. Smith works with his traveling pack—a 105mm telephoto, 55mm micro, and a seldom-used 35mm wide-angle lens. He limits himself to one Nikon body, although he usually has a spare in case of mechanical failure. Tri-X is the preferred film, for it is sometimes necessary, in dimmed bedroom settings, to push the film to twice its speed rating. When he gets back to the studio he will print up the pictures on Kodak Proof, a light, single-weight paper which has a textured matte surface and a slight sepia tone.

"I hate hard-edged glossy surfaces for my personal pictures," he says. "This paper is softer, warmer and very forgiving. It will take a thin negative that otherwise would be hopelessly flat and turn it into a delicate, impressionistic photograph."

Probably nowhere else is Smith's formal art training more evident than in these pictures. The play of light on flesh fascinates him, and he will violate all the acceptable conventions of exposure and composition, such as shooting blindly into the sun, in an effort to capture a different

The beginnings of a personal documentary—this one on a Paris rendezvous.

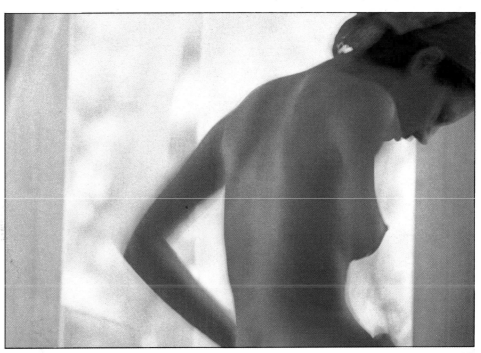

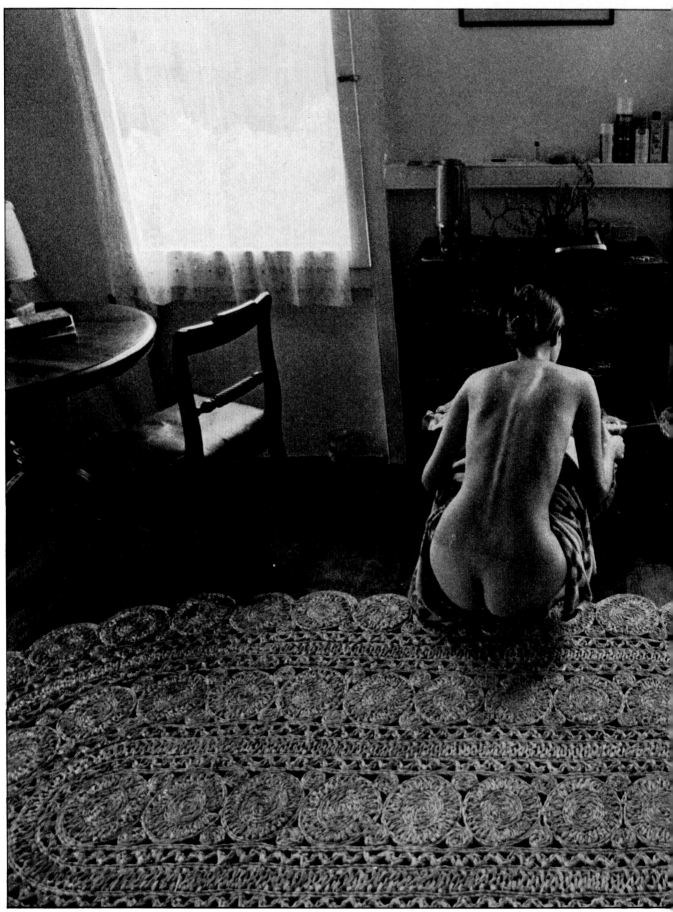

perception on film. His preoccupation with textures becomes exceptionally vivid. A spray of flowers in the room becomes a special filter for his camera as he shoots through them to catch the morning light wildly scattering flares throughout the picture area while his girlfriend frolics in the background (pages 70–71).

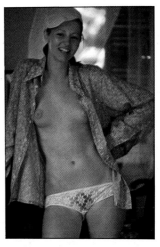

During another trip, this time to the island of Nevis in the Caribbean, they stayed in a beach house supported by stilts at the water's edge, facing the southern sky. It was like a set out of a Tennessee Williams play, with antique furniture and diaphanous curtains softly playing in the tropical breeze (at left). Windows on three sides flooded the room with sunlight. Lying on the bed (pages 2–3) and watching Ariel move about the room, he

Another found set. A beach house flooded with light from three sides became a studio while on vacation.

made pictures constantly. As the sun arced above them, the light would change in tone and intensity. Mornings it would be cool white shafts streaming in from the left with clearly defined shadows. As the day wore on, the light warmed and the shadows foreshortened until at noon, with the sun directly overhead, the light bounced into the room from all three sides equally. As the sun passed its zenith the soft shadows appeared to the left and a warm western glow poured in from the right, accelerating until it reached a rich red-yellow at sunset. Intrigued by this ever-changing pattern, Smith took careful note and some time later duplicated the room from the island cabin in his New York studio. Banks of strobes of varying power and masked with

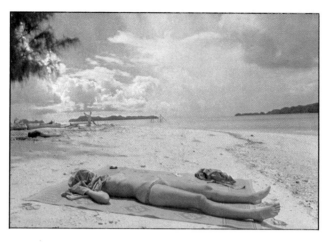

gels could be programed to duplicate the time and tone of day.

The found set later proved valuable in his commercial work, but on occasion the pictures themselves see publication. *Cosmopolitan*'s fictional text pieces occasionally lead off with a photographic illustration. Linda Cox will frequently

A wide angle was used to flatten the body baking on a deserted beach.

call to describe the situation in one of the upcoming stories, and more often than not Smith is able to pull a picture out of his books. "They are so poetic that they fit anywhere," says Cox. "I could probably find something to illus-

trate every story in the magazine if I spent a day poring through his private books."

On another level the books have a certain promotional value. Smith admits to being a lousy businessman. The commercial aspects of photography totally elude him. He has a full-time agent, Nob Hovde, who daily makes the rounds of the New York ad agencies. But Hovde's efforts are supplemented by the books Smith makes for models, friends and associates.

"Over the years I've learned that if you're going to test a person, it pays to do it right and really devote a lot of time to the project. A day is not too much. In the end I give the girl a lot of pictures. Some photographers would give her three or four, but I give her from fifty to a hundred, sometimes bound in a book. I think they deserve it. I'm indebted to these girls. First of all, they work hard. But a photographer owes much more to his model than another artist. A painter, by and large, creates images using a model as a reference point. But the camera takes in so much

Hand-holding a steady camera requires discipline, particularly in the early morning light.

more of her that it is only fair to give some of it back.

"These girls move around a lot. They visit more editors and art directors than I could ever see. When they take your pictures around in their books, it's like having a traveling exhibit. More than once a girl has been in a position to recommend me for a job. So I feel that I owe them everything that I can give them."

The evening is now morning. The fireplace is aglow with embers. The wine has made both Smith and his visitor sleepy. There's a long pause in the conversation as the visitor mulls over one final question that has been gnawing at him all along. At first he thought that it was out of envy that he tried to question Smith's motivation. After all, to spend one's entire life in the playful pursuit of sensual young women is hardly an altruistic aspiration for anyone. Does he ever tire of it?

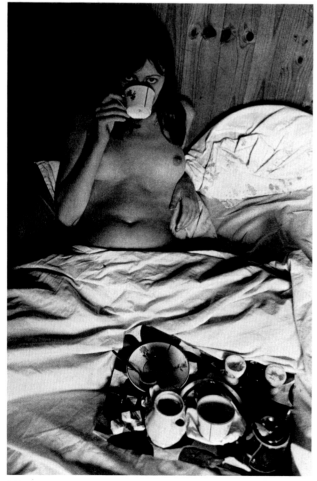

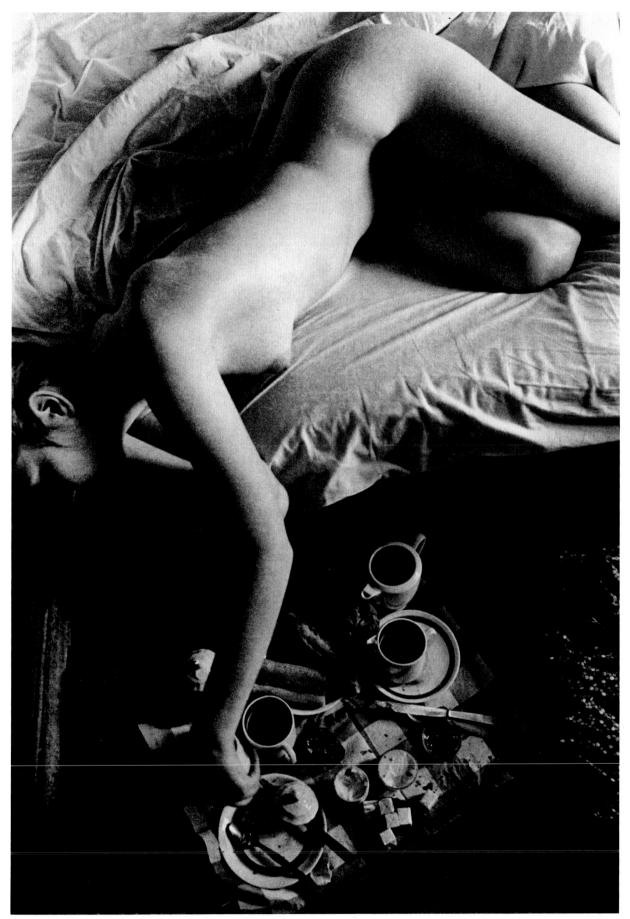

Smith used existing elements in his Paris flat to provide natural frames and filters for a series of personal pictures.

"**W**omen are an ever-changing and never-ending source of joy in my photography.** In them you can see elements of design and drama that excite you and encourage you to experimentation that is limited only by your own imagination. Their moods, styles, and attitudes make each one an original subject for the camera. You can dress one girl and undress her. You can make her up and scrub her down, you can put her in a set or against a plain background, and she'll give you a different photograph every time.

"You asked me if I question the validity of my work, and I say emphatically 'No.' There is no one else I'd rather be. I don't look at a lot of other photographers'

work any more because I've come to like my pictures best. I'd like to be remembered as someone who, in satisfying himself, brought some pleasure to other people. I think I live a great life, one that is of my own making. For me, photographing women will always be the greatest show in town.''

Walking home that morning, the visitor passed through Central Park. There it dawned on him that women are to Smith what the shadblow tree was to Steichen: always growing, always changing, in bloom and in repose, at all hours of the day, in all seasons of the years, a constant challenge to photograph, a delight to behold, and quite probably something that any man would be happy to spend the rest of his life pursuing.

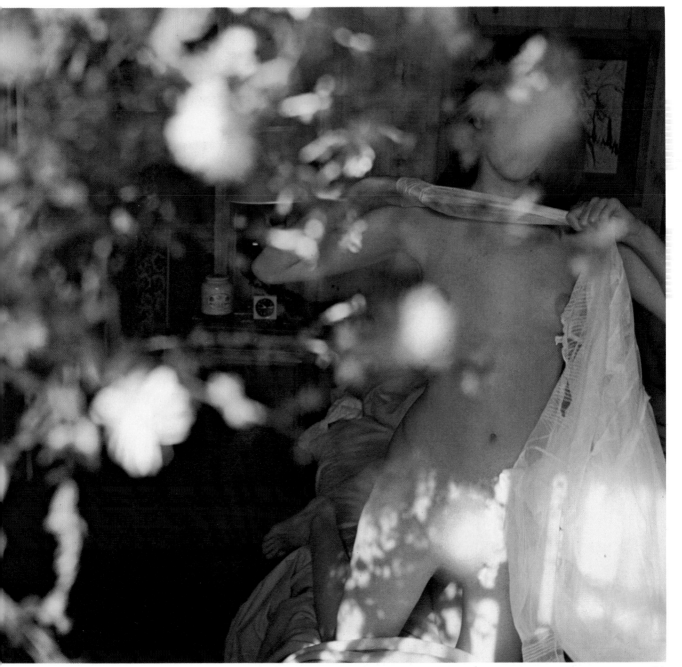

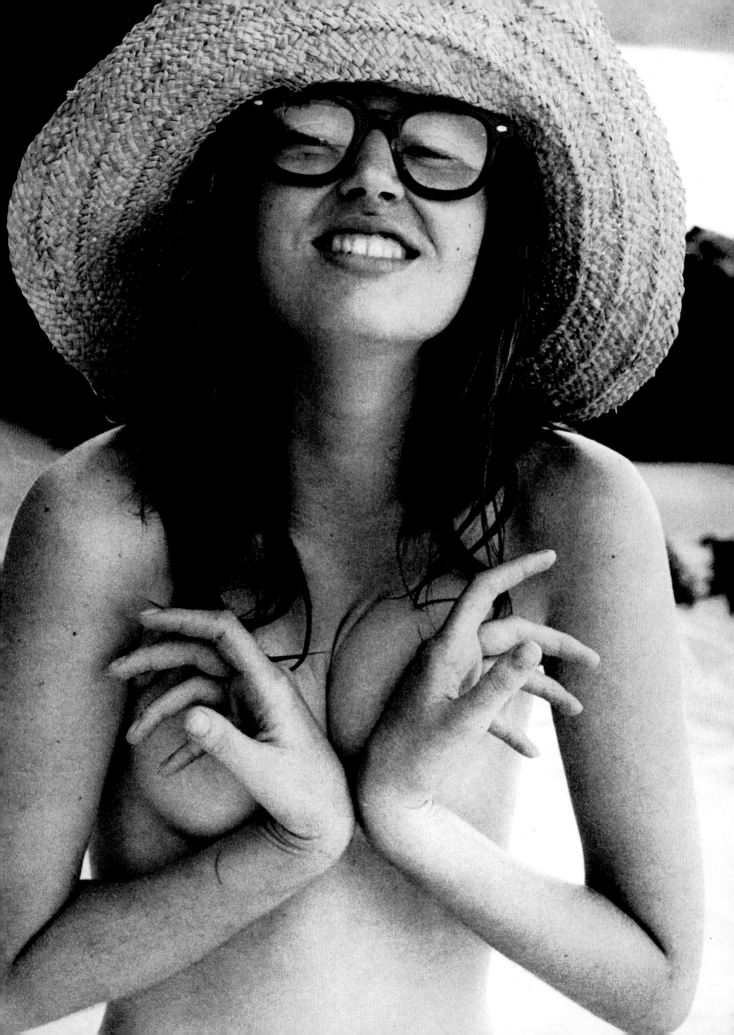

Testing the model

The girls on the pages of *Playboy, Penthouse,* and the other men's magazines are rarely professional models. They are "girls next door" discovered by enterprising photographers who find them serving passengers on airlines, working in theater groups, boogie-ing at discothèques or, as unlikely as it may seem, sitting on a stool in a drugstore sipping a malted—just like Lana Turner. One girl worked in a *Playboy* West Coast studio for a while as a stylist before a staff photographer took the time to look up from beneath his focusing cloth to notice her Playmate potential.

If they share a common trait, it is a vivacious look in the eye that projects a wholesome sexuality. The *zaftig* figures of the mammary-mad Fifties and early Sixties are becoming passé, and a more proportional figure is the rule today.

"If you were to pass one of these girls on the street," says a *Playboy* picture editor, "and she was without her Playmate drag—the magnificently-coiffed hair and impeccable makeup—you might notice that she was an attractive girl, but I'd doubt that you would give her a second look."

They're usually quite average-looking girls who have never given modeling much of a

thought because they lack the requisite bone structure or the height demanded by the fashion industry.

"One of our most popular girls was only 5 feet 2 inches tall," he says, and adds wryly, "maybe the reason she went over so big with the readers was because she fitted more comfortably into the 11x23-inch gatefold format than someone taller."

Although most of the girls in *Playboy* are discovered by staff photographers, photographs of others come from outside professionals or their agencies. They rarely come from the thousands of unsolicited photographs a year—usually snapshots made by readers of their wives and girlfriends—that the magazine receives. Most of these are speedily returned with a polite "No, thank you." Those who show potential are advised to be tested by a competent professional photographer with experience in nudes. Or their names are taken with the intent of arranging a meeting with a *Playboy* representative the next time he visits their part of the country.

"I get calls from girls all the time who want to be a Playmate," says a *Playboy* picture editor in New York, "and my first response is always 'Do you have any pictures?' I'd really rather not meet the girl unless she can show me how well she photographs. Personality and charm have nothing to do with it. She can be a dynamite-looking woman in real life, and yet freeze up before the camera. I want to see a test shooting. She has to be willing, and the photographer has to be talented. If she responds to the delicate seduction of his camera work, then

we may be on our way to a gatefold."

The man often called upon by the magazine to test potential models is J. Frederick Smith.

Yolanda is a bright, energetic 22-year-old working as an assistant buyer in a discount department store chain in New Jersey. She handles their fabrics, buttons and notions. She has a notion of her own—to get off this 9-to-5 treadmill that pays her $125 a week. Her restlessness and frustration get burned off nights at a local discothèque where her frenetic dancing often leaves her husky boyfriend out of breath. When he suggested that she might put all that energy to work dancing professionally in New York, where go-go girls make $300–$500 a week, her eyes lit up. Soon she was on a Manhattan-bound bus carrying a lot of courage and a little go-go costume hastily fashioned out of a bikini-bottom with two Band-Aids for pasties. The trip filled her with even more trepidation than the time when, as a child, she immigrated to America with her mother from the tiny Caribbean island of Culebra, which lies 20 miles east of Puerto Rico. When her mother decided to return to Culebra and the rest of her twelve children, Yolanda, then a plucky teenager, decided to stay to forge a new life. Tonight, she thought as the bus pulled into the Port Authority Bus Terminal near Times Square, was just another step.

The other dancers at the club eased her apprehensions by showing her a few steps and letting her watch their routines. When it was time for her to go on, she punched up her favorite

tunes on the jukebox (some pulsing rhythm-and-blues by the O'Jays) casually doffed her robe and did what came naturally. The bright lights obscured the admiring stares and it soon became easier with every number. By the end of the half-hour her tawny skin was glistening with perspiration.

During her break a woman patron introduced herself as a writer for *Oui* Magazine, and inquired if she had ever considered modeling. The woman left her card and told Yolanda that she would pass her name along to a picture editor. Some days later he called, and Yolanda, with her boyfriend along for support, visited his office. He was young, friendly and quietly professional. She was impressed that he wore blue jeans in the formal setting of an office that was surprisingly absent of sexy receptionists and pictures of nude girls. She had no pictures to show him other than some crude attempts at cheesecake made by a friend. Within a few minutes of talking with her, he knew that Yolanda was a potential candidate for *Oui* over *Playboy*. She didn't have that wholesome round-faced look of a Midwestern maiden that marked Hefner's girl-next-door. Yolanda didn't smile very much, but she had a smoldering look that seemed to be masked with a permanent pout. Her café-au-lait complexion and dark hair, cropped very short, gave her a desirably alien look that would fit *Oui*'s international image. There was an appealing aloofness to her that he liked. She was of medium height, and her form-fitting jeans outlined graceful legs and narrow

hips. From the loose-fitting top she wore he surmised that her breasts were small but firm. This examination was conducted while he explained the testing procedures and potential rewards without once looking directly at her body.

When he felt that she had decided to go through with it, he brought up the name of J. Frederick Smith. He quickly flipped through some copies of *Playboy* and *Oui* containing Smith's work and offered to take her down to meet the photographer in his studio, and a date was set.

T

he day Yolanda was to meet her photographer she was apprehensive, a bit nervous, but decidedly excited about becoming a model. She wore a pair of Levi's that would appear to be painted on except for the embroidery she had cleverly

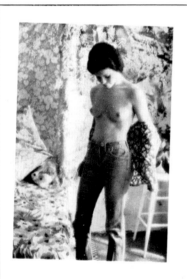

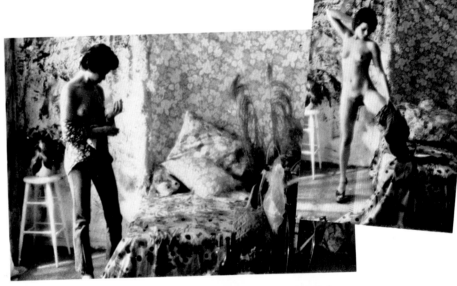

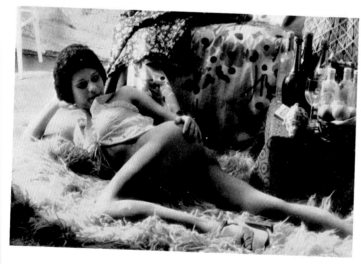

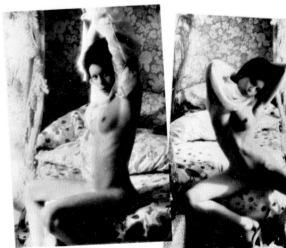

tacked to the hip pocket. A colorful print blouse was open halfway down her front.

When they entered the rambling studio, rock music was playing something in the background. Smith strode briskly out to meet her, flashing a cheery smile and a buoyant hello. When he was introduced to Yolanda his eyes came alive, and he would rarely take them off her for the rest of the meeting. When he ran off to put away her coat she sneaked a look at all of the pictures on the walls—fashion layouts for *Look,* spreads for *Cosmopolitan,* covers for *Redbook, McCall's* and *Playboy.*

He led her to a little alcove off of the working area where director's chairs surrounded a low oak table laden with fruits, nuts and an assortment of wines and liqueurs. Behind it was an overstuffed couch piled high with brightly-colored throw pillows.

Playboy staff photographer Dwight Hooker once said that ''when the girl turns up at the studio, it's like meeting your bride at an arranged marriage.'' The courting rite, with all its attendant rituals, has now begun.

Smith questions her about her job, tells a few anecdotes about dancers he has known, and appears intensely interested in everything she says. He has visited the little island where she was raised. After a few minutes of small talk, he gets around to talking about photography, apparently having made up his mind that she would be a good subject before his lens.

''I have no preconceived ideas about what we'll do,'' says Smith.

"I'll build a set. Something like a little house by the sea that you find in Culebra. There will be lots of things around to play with, and we'll just make beautiful pictures together."

"You can't do anything wrong, really. All you have to do is just be Yolanda. Pretend you're a thousand miles away from here and play with what's around you. Leave it up to me to find the interesting moments."

She seems convinced, and they plan to shoot the test the following Saturday, when they will be free from interruption

by telephone, arriving messengers and the necessary business of his photography studio.

Yolanda arrives early Saturday, a bit nervous and full of animated chatter. Smith is there waiting. He has been there for hours, in fact, putting the finishing touches on the set he had built the night before. The heat in the studio has been turned up a notch. There are fresh flowers in vases, fruit in bowls and a tray of nuts for munching. From somewhere in the back of the studio wafts the smell of fresh-perked

coffee. Everything is in its place and ready to go, except, Smith senses, Yolanda. He sits her over in the alcove to let her talk herself down. Wine is offered. She chooses anisette. He pours himself a glass of Beaujolais, but barely sips it.

He gets her to talk about her work, and when the apéritif has worked its way he asks if she brought any of her favorite clothes to be photographed in. She produces a custom-made string bikini that she has fashioned out of an old pair of Levi's, and some clunky platform heels,

again trimmed in her favored denim. Smith admires the handiwork, and then brings her into the dressing room. Laid out on the shelves are some of his favorite costumes. She pauses over a frayed pair of pink Levi shorts, cut off crotch-high, and a work shirt so tattered it is impossible to discern front from back, or even where the sleeves are. He approves her choice but wants to save them for later. To start he gives her a billowy cheesecloth shirt to put on, and decides to keep the jeans she came in. He asks her to pick out a dressing gown to wear during breaks and returns to the set while she prepares herself.

Stage flats have been erected across the back wall, with one off-set to provide an alley from which to conceal a background fill light (see diagram, set-up A). One flat has a gay wallpaper pattern on it, the other has been streaked with blue paint from a nearly dry brush. From afar the effect is that of a stucco wall. The left wall has a large lattice-work simulating a window. Behind it hangs a sheet of opaque plastic that diffuses the main strobe light. When it fires, the window panes scatter a soft pattern that approximates natural outdoor light. The right wall is a flat that is completely covered with black felt. Another strobehead, covered with a red gel, is bounced onto the felt to absorb most of the intense red, and gives off a tinge of pink to enliven skin tones as well as to throw off the balance of the harsh white strobe light. A bed covered with pillows is stage center, with end tables containing a spray of flowers and another with a bowl of grapes and tanger-

ines. And in a bit of whimsy, Smith has placed at the foot of the bed a woman's bike.

When Yolanda appears he makes a Polaroid—not so much to test the lighting, for this was worked out hours before she arrived—but to orient her to the perspective of the camera. He shows her the picture so that she may identify with the fantasy world he will see, and not the disconcerting array of flats and booms erected in the middle of the studio.

He doesn't use any technical jargon. In fact, all the mechanics of photography have been carefully hidden away. Except for a fill light with umbrella standing behind where he will shoot, all the lights are concealed and their cords coiled and tucked away. Off the set is a waist-high cart lined in green felt containing two Nikon F's, their lenses—a 55mm and 105mm—and a carton of Kodachrome 64, of which several boxes have been opened, their spools ready to be consumed by his cameras.

"Okay, Yolanda, let's pretend that this is your beach house and you just came back from town. It's a very hot day and you want to come home and rest and relax. You light up a cigarette, then you sit by the bed, then get up, go over by the window, maybe have a tangerine, stretch out on the bed and get comfortable. Just walk through this almost in

slow motion. If I see something I like I might ask you to do it again. Just do it in your own way and I'll follow you."

She begins to walk through his scenario, awkwardly at first but then responding to his smooth, deliberate coaxing and constant encouragement. "That's nice, move a little more this way (click), that's good (click) now watch out the window, that's fine (click) everything's moving v-e-r-y s-l-o-w-l-y (click) enjoy your cigarette (click) that's it *exactly,* good (click). . . ."

The soliloquy is a constant patter of subtle direction interspersed with flattery. He never tries to halt her actions, but gets her to modify them. It's as if he's toying with an elusive puddle of quicksilver in the palm of his hand, marveling at the infinite variety of configurations it assumes, and yet controlling the outer limits of its travels.

He moves with surety in his tight-fitting faded denims tapering to casually buffed Frye boots, and conjures up the image of a little dancer. He moves very fast, in and out, never coming closer than fifteen feet from her with his 105mm lens, then quickly retreating to pick up a picture of her in the whole set.

And all the time the chatter. "There it is (click) it's so hot you want to take your shirt off (click) good (click) go ahead, loosen it some more, great (click) that's it (click) then s-l-o-w-l-y pull it off, good (click) this way more, good (click) let it casually fall to the floor, that's beautiful (click)."

The rolls fly through the camera. He uses no motor drive. Pulling the camera away from the eye after each exposure to advance the film

causes him to recompose, resulting in a new picture each time. Unlike the younger generation of photographers wired to their electrocharged Nikons, whose thunder-thumbs spurt out a staccato of motor-driven pictures, Smith makes one deliberate exposure at a time. Going through the boxes of his processed film, one rarely finds duplicates among his pictures.

After several rolls she is comfortable being in front of him wearing only the briefest bikini underwear. She is languorously sprawled on the bed, lost in her own reverie. He quickly returns to the cart to change film, but to keep the spell alive he keeps up the monologue. "That's it, you're just a little girl who's run away and couldn't care less where she was going." All the while his hands fly over the tray, changing film and lenses. It's like a well-choreographed pit stop at Indianapolis—not a gesture wasted, not a moment lost. As he advances the fresh film, he increases the volume of the stereo.

"All right, lie back on the bed, kick your feet up in the air, pretend you're dancing on the ceiling. Great. (Click)." Gradually he gets her to peel off her underwear "Slowly, (click) that's it, tease me, (click) great." As the rock music picks up the tempo so does she, and he encourages her to dance. First on the bed, where she loses her balance, nearly falls, then breaks up into convulsive laughter. "Great, I got it. That's the best picture you've made so far." She has lost all her inhibitions now. During the next film change he brings out a tray of scented body oils—lemon, lime, cherry and

banana. He encourages her to sample them and shoots while she sniffs the various fragrances. Soon she is applying it, first to her arms, then neck, then between her breasts. "Go ahead, do it all over. (Click). There is nobody but you in your own little world. (Click). Beautiful."

He is shortening his distance now, working within five feet of her. His hands move rapidly over the camera, changing focus and adjusting the film. The shutter speed indicator has been taped at 1/60th to prevent him from accidentally knocking it out of sync. "That's it now, put your shoes on again, make an elaborate little game out of it. Yeah. (Click). Now throw that leg in the air. It's a beautiful leg. (Click) Send it up a million miles into the air, (click) fantastic (click)!"

A bowl of grapes and tangerines are introduced. Close-ups are made of her tearing their skin off with her teeth, lolling the grapes with her tongue, and letting the whole bunch trail over her body. Time for a bath.

Out comes an old washtub. Warm water is hauled from the lab and he quickly fluffs up a bubble bath. She arranges herself in it, and when she has difficulty getting the suds over her back as he wants, he reluctantly steps in, scoops up a handful, and flings them on her back. The gesture is awkward and out of place. He seems to go out of his way not to touch her, no matter how innocently, refusing to let his physical presence intrude upon the moment. She picks up on this, and now the seducer becomes the seduced. Her gestures become much more pro-

vocative and uninhibited. She is massaging her breasts with real passion. She is trying to entice him, and he is responding—verbally.

The session becomes much more erotic. She caresses herself, massages herself, writhes on the bed, pouts, laughs, mocks, challenges. And Smith responds with every trip of the shutter.

When it has gone as far as he wants to take it, Smith calls for a break. Fifteen rolls have been shot in an hour. He has run through a dozen different situations on the set, and made them all look different. He is in complete control of the model, and now will put her to the ultimate test—working alone with the barest of props in front of the seamless paper.

The action shifts to the other end of the studio (set-up B). He changes the station on the radio, aware that rock programming repeats itself during the hour. The volume goes even higher. One light is on the background paper, another with an umbrella is over his left shoulder. A fan is blowing on her from the right. Wearing Smith's treasured cut-off Levi's and raggedy shirt, Yolanda takes her place on an X taped to the floor. He encourages her to go through her go-go routines, but they are too theatrical for still photography. He lets her boogie up a storm with the fast music for a while,

then slowly reins her in, getting her to stretch out her gestures and enact her movements with more subtlety.

A floppy hat is tried and discarded. He puts her through a slow strip. He throws her a small scarf and a challenge: "See what you can do with this." She covers her breasts with it, then her waist, then her behind, before draping it over her head as a veil, looking like a naughty novitiate just bounced from the convent.

This session moves faster, as Smith concentrates on her expressions, quickly grabbing the spontaneous moments that she throws off. The grand tapestry of the set has been replaced by no-seam, and allows him to work on the nude form alone. He never holds her to a pose very long before he shoots it. With every new roll of film he introduces her to a new costume—a lacy antique shirt, then a red hat, then a tattered T-shirt, then a chiffon veil.

He becomes more excited with her every gesture, with every variation she gives him. Elton John comes on singing "Lucy in the Sky with Diamonds" and Smith quickly punches it up to full volume. The pulsing tones from the Fender bass push her on. She is riding on a natural high, and he coaxes her ever higher. She is *convinced* that she is giving him something that no model has ever given before. "That's it (click) tease me (click) fantastic (click) great, great, great. . . ." Within an hour another fifteen rolls have burned through his camera. The model has finally come down, a bit drained, with a look of blissful exhaustion. The photographer is satisfied.

Technical section

The fantasy worlds portrayed by skilled photographers in the men's magazines are designed to beguile their readers. Photographers outside that business are often swept along by fantasy, too. In this book, J. Frederick Smith shatters some myths about nude photography, and as a result it should be easier for any photographer to experiment in this environment.

Smith's technique and equipment are readily accessible to the average photographer, but developing an eye like Smith's takes practice. His eye improves every day that he "sketches" in his studio, experiments with new techniques, and tests the women he meets.

The prime requisite of success in this field is a healthy attitude. As we have seen, the personality and character of the photographer must inspire trust and confidence in a model who, inside, may be fighting years of repression about her physical charms and is now about to undress in front of a stranger. The women Smith celebrates are not, in real life, the aloof and gorgeous fluffs of femininity that luxuriate around the studio set for $65 an hour. Models are just people who, by chance, have been blessed (or cursed) with physical assets that are in vogue and potentially marketable. They have made a decision—sometimes subconsciously—that they want to revel in the limelight that photography affords. Smith, for example, never coaxes a girl into posing for him. He

leaves the decision up to her, but the example of his skillful camera work and professional bearing helps her make it.

For a beginning, he says, "I want everything to appear as simple as possible. Everything has been prepared ahead of time. Setting up in front of a model is unprofessional. It wastes time, and casts a damper over the entire shooting. I want it to look as uncomplicated as possible, so I never get technical with her. I always try to give

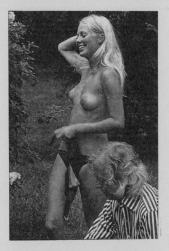

her a place to dress that is comfortable and private. It's strange, but in spite of the fact that she will be naked in front of you, nothing casts a pall over a shooting like having a leering photographer watching the model undress.

"The only thing I want her to be aware of is me and the camera (which become one), and herself. I try early on to establish rapport and convince her that it will be an exciting experience. If the girl is new to this, or unsure of herself, I give her a vague idea of what we're going to do, just to allay her apprehensions. I might walk through it just to assure her that I know what I'm doing. Actually, I don't know what I'm going to do and I don't want her to know. I want it to be a new, exciting experience for both of us.

"Initially, I want her to be very aware of the camera. I do a lot of talking to her, encouraging her when she is

doing right. Certain key poses evolve, which lead you into other poses—it all comes automatically. As a session progresses, she begins to develop a sense of where the camera is at all times. She begins to know when she looks good. It's up to you to develop this in her, but when it happens she becomes much less inhibited, less mechanical in her responses. The directing becomes easier. She responds effortlessly to your suggestions. You and the camera become an unseen presence as she becomes more involved with herself. You never disappear, of course. It just seems that way. You're always out there somewhere, but in complete control of the situation."

It is not as easy as it sounds to be so relaxed and self-confident, especially if your model is a self-conscious young woman who is not at all comfortable in a see-through blouse or in nothing at all on her own bed. But it's a matter of priorities. *You* are there to take pictures, to see a girl on film even more beautiful than she is in real life, to create a mood and to take advantage of every modern technical tool and technique you can afford. *She* is there to be romanced by your lenses and to glow in your lighting. You are a team united by photography with lively beauty as

your goal. Fortunately, the tools and techniques employed by Fred Smith are basically simple. His love of light and of direct camera methods show up in all his pictures.

THE REALITIES OF LIGHT

Softness is a predominant quality of Smith's lighting. Barely does he use a light aimed directly at a woman; he would rather "bounce" it off a surface, a wall, reflector or photographic umbrella, to soften the effect, moderate or eliminate shadows, and create what sometimes seems to be an interior glow of illumination.

In the beginning, when photographers are learning the principles of good lighting practice, they have a tendency to do portraits with one main light, a fill light for the shadows, a background light (if appropriate) and occasionally, a hair light or rim light that brightens the edge of a face or head, looks glamorous and helps to separate the subject from a background. Lots of conventional portraits are still shot in studios and living rooms using variations of the above, but the joys of indirect, bounced or reflected light (three ways of describing the same effects) became apparent to most professionals—and many amateurs—years ago.

Smith recalls, "I think everybody has a tendency in the beginning to overlight everything. Now the more I shoot, the less light I use, meaning the fewer light sources. In fact, I try to think of a single light source whenever possible, and I compound it with reflectors."

As examples, the playful poses on pages 6 and 7 were made with one bounced electronic flash on the model. Against the dark background she stands out simply and shadows are muted. On page 30, the kitchen suggested in a studio setup is illuminated by one electronic flash bounced onto the model from a reflector in front of her and onto the background from

two other reflectors there. (See diagrams.) Both photographs on page 49 were similarly lighted, but the sexy shoe shots on pages 22–23 and 24–25 were made with three bounced strobes instead of one. In the diagram you see that the strobe at left was at full power and reflected from two umbrellas onto the background wall, while the one at right was at one-half power and aimed at a reflector to light the legs.

Smith uses Thomas Studio 1200 strobe units, a brand of high-powered studio electronic flash with reflectors and pilot lights on stands and electric power packs separate on small rolling platforms. Within the reflector dome are both a flashtube and an incandescent bulb (called the pilot light or "modeling light") by which the photographer sets the lighting effect—but not the exposure—before shooting. That incandescent bulb is handy, but you can place a small reflector flood bulb next to your portable electronic flash unit and achieve somewhat the same effect.

Professional studio strobes are marketed under brand names such as Broncolor, Ascor, Bogen, Calumet, Strobasol, Norman Enterprises, Rollei, Smith-Victor and Speedotron. Prices range from around four hundred to several thousand dollars, and all of these require plug-in AC connection, which means you cannot operate with batteries on location.

Smaller Strobes

While a studio unit might be rated from 250 to more than 1,200 watt seconds (a unit of power indicating light intensity), the average *portable* electronic flash unit with which most of us are accustomed puts out from 30 to 100 watt seconds. The latter units are compact, versatile, can be camera-mounted, and operate on various types of batteries anywhere. Many modern strobe units include built-in light-measuring sensors; you dial in the film speed, and the sensor then automatically quenches the flash for proper exposure according to the distance you are from a subject. This thyrister circuitry helps to conserve energy and may give you 300 or more flashes from a set of tiny batteries. If you are close to a subject, you can even shoot with a flash duration as short as 1/50,000 second with most small-thyrister-equipped portables. These small units range in price from about $40 up to maybe $300.

Despite the relative economy and portability of small strobe units, most professionals cannot use them except for specialized situations. A studio photographer such as Smith must have much higher light output (watt seconds) in order to bounce the lights onto subjects that are either large or many feet from the light source. As an example, if you have a small strobe unit with a guide number of 35 for Kodachrome 25, you can aim it directly at a subject from about four feet and set your lens to about f/6.3. At 10 feet, you must open to almost

Studio Strobe Lights

Strobasol

f/2. And if you aim the average small strobe into a reflector, you need at least two stops additional exposure. In other words, a low-powered unit gives insufficient light when bounced or reflected in conjunction with slow color films. In such situations, a large studio unit with a guide number of 200 and up offers more versatility.

If you wish to experiment with soft lighting effect, and have only a small strobe unit, switch to a faster color film such as High Speed Ektachrome (ASA 160), or a fast black-and-white film such as Tri-X (ASA 400). Place your reflector within two or three feet of the subject and concentrate on portraits. In this way, you will have enough light to shoot at around f/4. You should makes a series of test exposures and keep notes. You may also soften the effect of a strobe aimed *directly* at someone by attaching or holding a diffuser in front of the light. Commercially-made diffusers of spun glass are available, or you might improvise one from frosted acetate bought at an art supply store.

Smith uses his Thomas strobes at one-half power when his reflectors are set close to a subject. Studio strobes are often designed for variable light output; also, two, three or more lights may be operated from a single power pack. Even when its power is divided by two or three, a big professional unit has enough to light a subject very nicely with K25.

Medium-size Strobes

There are also battery-powered two-piece strobe units with guide numbers for K25 between 85 and 125, made by Braun, Ascor, Honeywell and Ultrablitz-Bauer. Most of these can be adapted to bounce lighting with slower color films, and they list between $200 and $350. Rollei also makes a medium-powered studio-type strobe in one piece that is portable and operates on AC for about $550.

One new medium-powered, compact electronic flash on the market that combines plenty of light with portability is called the Strobasol X8000. Unique about it is a narrow hole through the center of the unit into which you can place the shaft of an umbrella reflector—a feature that is both convenient and efficient. The Strobasol X8000 includes power pack and light in a single 7-pound unit. It has a pilot light and offers a guide number of about 125 with K25. In mid-1975 it listed for $425. It is made by Larson Enterprises, Inc. This strobe operates only on AC, but packs neatly in a small case.

UMBRELLAS AND REFLECTORS

Outdoors, Smith uses large white sheets of cardboard as reflectors to bounce sunlight into shadows and make backlighted portraits soft and beautiful. Indoors, he uses a variety of umbrella reflectors on stands. Smith likes to travel extremely light on location, but if he wanted to, he could also use umbrellas outdoors. These handy light-bouncers are made of materials such as white nylon and aluminized MYLAR fabric, and come in round, square and multi-sided shapes in sizes from about 30 inches up to more than six feet in diameter. Uncle Sam Umbrella Shop in New York manufactures a line of moderately priced umbrellas ($8 and up), while Larson Enterprises offers a popular line of Reflectasols from about $28 up. Check your local camera shop for other brands, and you will also find out about the necessary stands, adaptors and clamps you need to go with them.

Obviously, you can bounce photoflood and quartz lights as well as electronic flash into reflectors, but again the light intensity is cut about two stops. With average 500-watt bulbs, this allows little latitude for shooting action. Since strobe is fast and concentrated, doesn't pour a lot of heat on a subject, and can give many times the light output of a 500-watt bulb, it is the favorite of pros and many amateurs. In large studios, "flats"—large, movable, white wall-like sections—are also built as reflectors that can be shifted up and around as needed.

STROBE EXPOSURES

There are three methods of determining correct exposure for electronic flash. The old reliable way is by guide number, a number supplied with the unit and usually tied into an ASA 25 film such as Kodachrome 25. Guide number charts and conversion tables are available in data books. You simply divide the number of feet from flash to subject into the guide number. The answer is your f-stop for that specific film and unit. For instance, with a guide number of 50, at 10 feet you would shoot at f/5. A small margin for error is built into all film, because exposure can be influenced by the reflectivity of walls and subject, by your ability to guess or measure distance, and by equipment variables.

The second way of determining exposure is easier because it's automatic. A majority of new compact portable strobe units are sensor-equipped to provide automatically the right amount of light for a given distance, film and subject. A few years ago these units cost at least $75–$100, but today they're available for $30 and up. You can't get quite the same bouncelight effects that J. Frederick Smith gets with such a tiny unit, unless you stick to head-and-shoulder shots, but there are many things you can shoot with satisfaction.

The third method of mea-

Comparison of Reflected Shapes

Umbrella Reflector

More localized or limited dispersion of light

Softer effect

Minimum amount of light passes through

White Reflector Wall or Panel

Wide dispersion of light

Light less diffused than with umbrella

surement is by electronic flash meter, the technique Smith and all studio-based professionals use. A strobe is plugged into the electronic flash unit, film speed is dialed in, and when the flash is fired the light intensity registers on the meter either directly in f/stops or in numbers that you convert to f/stops on another built-in dial. It is the only way to meter flash accurately in changing circumstances. Smith uses a Thomas meter, no longer on the market, but Calumet makes a good model for $79.50 list, and others are manufactured by Balcar, Bowens, Gossen-Ascor, Honeywell-Wein, Minolta and Sekonic.

Unless you do quite a lot of shooting with electronic flash, especially with large AC-powered units in changing circumstances, you don't need a strobe meter but can rely on guide numbers or automation. You may also use a Polaroid Land camera Model 180 or 195 to make lighting and exposure test shots, or buy a Polaroid back for certain cameras such as the Nikon, Bronica, Hasselblad or Kowa Super 66, although some pros find these units cumbersome.

DAYLIGHT, INDOORS AND OUT

Although Smith does his share of photography by electronic flash in a studio, he shoots as often by daylight, either outdoors or by window light in ordinary rooms. Many examples are included in this book. In fact, Smith sometimes arranges his strobe to simulate daylight and achieve the glow of sunshine bouncing around a

room.
As an example of Smith's feelings about natural light,

turn back to the nude on pages 2–3. Smith and his companion Ariel were vacationing on a West Indies island, at a beach where individual cottages were set on stilts. "We had just come in from swimming," he recalls. "It was siesta time and I was just lying on the bed basking in the light from huge windows on several sides of an L-shaped room. It was like a great natural studio, and in fact, I've duplicated such a corner in my own studio with electronic flash behind the windows we built.

"Anyway, light came from at least three sides and rimmed her body with a halo (see diagram). Lying on the bed, I instinctively included my own feet with the 35mm lens. This was our own intimate, special diary, but it also adds interest to the picture later when people think, Who is the guy?"

Smith considers such self-made photo projects to be a kind of "sketching" which often leads him off to other directions professionally. He explores different possibilities with a camera, and the resulting sketch book becomes a fine research file for future studio pictures as well as a personal record.

On pages 4–5 is an outdoor shot that typifies Smith's way of working on location. In this fantasy illustration, part of a series for *Cosmopolitan,* the super-expensive Maserati car was important, and Smith chose to shoot in late afternoon when an even light was coming through the windshield, and there was some glare off the chrome. Although he occasionally uses a white cardboard reflector outdoors, in this case he had the model move in and out of the shadow area until she was illuminated in balance with the rest of the scene. Using his favorite Sekonic exposure meter, he took a reading on the bright foreground and on the girl's face, and set the lens opening at a compromise exposure between the two extremes. For both mood and image impact he wanted to

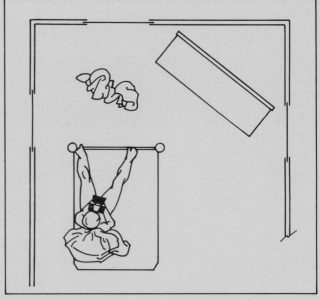

confine the partial figure of the man to the dark background and allow the girl to contrast against the car.

"I hesitate to use the reflectors very often," Smith explains, "because they inhibit everyone. I'm trying for the emotional moment when models react to a situation, and I'd rather make the picture happen than methodically piece it together like a still life."

For the girl-in-car Smith chose a 20mm lens, an extreme wide angle that would hold in focus both the foreground door and the girl. He says, however, that his favorite focal length on the 35mm camera is the 105mm lens, which he uses about 75 percent of the time, followed by a 55mm Micro-Nikkor and a 35mm wide angle. For a professional of Smith's status, this is an austere selection of equipment, and it can set an example for simplicity that serious amateurs might follow.

As for his use of the hand-held Sekonic meter: it serves as a double-check against the reading given by a built-in camera meter, and it survives as part of the conditioning from his start in photography. Originally Smith used a Rolleiflex and then an 8 x 10 camera, and, of course, neither contained its own meter. The habit of using a meter separate from

the camera has stuck with him as a safety factor.

Smith is high on outdoor locations. "I like not knowing quite where I'm going to shoot, and then using what I find," he explains.

"I grab for the light, and for the mood of a place." As an indication of the variety he might find within a single set of pictures: The photographs on pages 26 and 29 (top) were shot on a Manhattan rooftop, with tarpaper providing the texture behind the model for what Smith calls a funky background. The picture at the bottom of page 28 was made on the Bermuda seacoast with no artificial background, and seamless paper in the studio formed the background for the top picture on page 28 and its sister photograph on page 31. "Every landscape I look at," says Smith, "I think of putting a figure into it."

While he does work in bright sunlight, which he prefers sometimes to see coming from behind the model, Smith (like so many pros) likes an overcast or hazy day for its soft, shadowless qualities. He uses a Skylight filter occasionally, knowing by experience when he wants to warm up the chilly tints of cloud-cast light. And he doesn't avoid rain or fog. Finding a room with windows that offers a reasonable light balance isn't easy, but

Smith seems to excel at it. For instance, he shot the picture on pages 8–9 in the model's apartment with illumination coming through east windows. He added no artificial light, nor did he use reflectors, because his mobility was important and he was after a "painterly" quality as well. One aspect of this approach is to shoot at slow shutter speeds and wide-open apertures, in this case 1/15 second at f/1.4. "I like a very shallow depth of field," Smith avers. "It creates an atmospheric effect. I've learned to hold the camera successfully at one-quarter second and even longer if necessary."

As an adjunct to "taking the hard edge" off pictures of beautiful women, he often tapes a Softar to his Nikon to smooth over blemishes, rough skin and obliterate pores. The Softar, made by Zeiss for Hasselblad, looks like a filter that is dimpled with an array of little depressions that are actually "lenses" themselves. The Softar attachment comes in three different degrees of soft-focus especially for portraits. They attach to the front of a Hasselblad lens by bayonet mount, but need to be taped to other lenses with which they are not designed to couple. In addition to pages 8–9, some other photographs made with a Softar can be found on pages 6–7, 26, 27, 28, 30, 34–35, 36, and 47.

In contrast, Smith sometimes takes pleasure in making sharp sun work to his advantage, and the two nudes of Ariel at the top of page 16 are from a series of "shadow pictures" he shot in the South Pacific. Using a 35mm lens on his Nikon, he composed for figure and shadow, enjoying the wonderful silvery quality that happens where sand and water meet. He walked backwards when Ariel came toward him and followed her forward as she turned around. Although he owns a motor drive for his Nikon, he seldom uses it, preferring to

maintain contact with the model—and reframe the picture—in the tiny intervals when he takes the camera from his eye to advance the film.

To sum up Smith's feelings about outdoor situations: His "ideal light" is backlight, especially when it seems to add a faint halo around a model's head. Otherwise, he enjoys muted daylight under clouds or haze, and he follows through in the studio by always bouncing his lights to achieve a natural glow that adds to the sensuousness and glamour of his subjects.

A CHOICE OF FILMS AND PAPERS

Consistent with Smith's desire to create an atmosphere around his models, he chooses Kodachrome 25 (formerly Kodachrome II) "whenever I can get away with it." By that he means when there is enough light, even for slow hand-held exposures. He will, however, switch to Ektachrome-X (ASA 64) or High Speed Ektachrome (Daylight ASA 160, Type B, ASA 125) when he needs extra film sensitivity to get more depth of field or faster shutter speed. For black and white he favors Tri-X rated normally at ASA 400 and developed in D-76, a fairly contrasty developer that helps the reproduction quality of images made in soft lighting. There's nothing tricky or esoteric about Smith's choice of films.

As for black-and-white printing papers, Smith uses two quite different Kodak products, depending on the purpose of the picture. For reproduction he usually settles on Polycontrast F, which has a standard glossy surface. Media clients expect the rich blacks and full tonal scale of this kind of paper, but for his personal use Smith

turns to Portrait Proof R, a "tweed" textured matte surface which serves to soften images and give them a warm tone that enhances pictures of lovely women. Many camera shops don't stock Portrait Proof, but they will order it on request. Although, it is a proof paper, it does not fade when processed in the conventional manner.

Both types of paper are developed in Kodak Ektaflo, a concentrated liquid developer that is diluted 1:9 for processing. Type I Ektaflo is recommended for neutral or cold-toned papers such as Polycontrast; its characteristics are similar to Kodak Dektrol, a popular paper developer that may be more familiar to you. Type 2 Ektaflo is for warm-tone papers such as Portrait Proof.

Dupont's Varilour variable contrast papers are similar to Polycontrast, with a very white paper base and great exposure latitude. Both brands have their partisans among professionals, along with Agfa's Brovira line.

SMILING GIRL [pages 10–11]

Typical of Smith's use of the 105mm lens is this portrait from a test shooting out in the country. Exposure was 1/500 at f/11. Smith never uses the Softar lens with black-and-white pictures, preferring to control image softness in the darkroom. His assistant does all the film processing and most of the printing, which Smith admits he gets into "only as a luxury

on weekends when I have time to play."

TWO FACES [pages 12–13]

Working in a model's apartment that contained many textures and shapes, Smith dubbed it a "photographer's paradise." He shot by the natural light from an east window of a penthouse about 15 floors up. In line with his feeling that models offer lovely potential when they express fantasies, he intruded as little as possible, shooting Kodachrome 64 with his 105mm lens wide open (f/2.8). Because of the great contrast between the foreground faces and the background light, he bracketed a series of shutter speeds to capture all the possibilities.

SHOES [pages 22–23, 24–25]

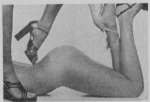

For a fashion spread on shoes, Smith came up with an approach using two models with delightful legs that are shorter than the average model's. To expedite the girls' positions, he hung a bar out of camera view for them to grasp. Seamless paper covered the background and flowed under a box covered by a large sheet of heavy white plastic which reflected

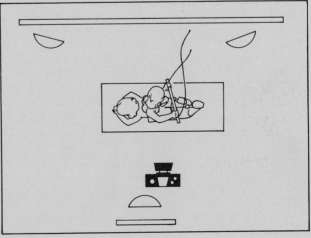

light up under the models. The models were standing at Smith's eye level on the plastic platform. One electronic flash at full power was bounced from overhead while two more strobe lights were reflected off the background. (See diagram on page TK.) Light blended and spread softly on and around the girls' legs as Smith exposed Kodachrome II through a 105mm lens with Softar attached. His electronic flash meter gave him a reading slightly over f/8, but he set his aperture squarely at f/8 for a minimum overexposure that produced a pastel effect.

TUESDAY'S CHILD, THURSDAY'S CHILD [page 28]

These two pictures present a neat contrast of conditions. For "Tuesday's Child," Smith had the model in a striding position and a small electric fan at the right blowing her drapery. Two electronic flash units were used, one reflected from an umbrella at the right and another brighter one reflected as a sidelight from the left. Smith's 105mm lens had the Softar taped on, and he shot at f/11 with Kodachrome II.

The "Thursday's Child" model, whom Smith describes as "very voluptuous," was elongated by the use of a 20mm lens near a Bermuda cliff. A wide-angle lens can distort a face when used closeup for a portrait, but the careful application of a wide-angle effect in relation to a whole figure can provide a controlled exaggeration. In this case, it made the model seem taller than she is. If you want to experiment with such effects, and you have a single-lens reflex camera that will show you exactly what a lens is doing, try shooting from knee-level up at someone and then shift the camera in all directions to see the amount and type of distortion that is possible. Whether you use a 20mm, 21mm, 24mm, 28mm or 35mm lens on your camera, distortion will be noticeable from many angles.

The shorter the lens, the more dramatic the distortion becomes; it can border on the grotesque if you are not careful.

FRIDAY'S CHILD [page 29, bottom]

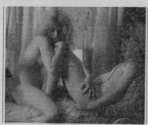

As fond as he is of real, workable rooms, Smith often elects to build his own sets in the studio to suit specific needs. Here a window was constructed with drapery over it and diffused electronic flash behind it. Another strobe unit was reflected from a large umbrella to illuminate the couple from front and side. By measuring the brightness of each light with his electronic flash meter, Smith could balance them, which means that he moved the front light back and forth until he knew it would give just the effect he wanted in relation to the backlight coming through the curtains. The film is Kodachrome II; the lens was 105mm with Softar.

If you have no strobe meter, you can estimate the balance of two or more lights either by substituting flood bulbs in their place and metering them, or by using guide numbers and measuring the footage. Equal-strength lighting from front, side or back is more likely to be monotonous than several lights set at different distances to provide variable light and shadows.

SATURDAY'S CHILD [page 30]

Here is another improvised setting, with a throwaway table from the basement working with the tile floor of the studio to suggest a tenement kitchen. One unit powered two lights (or *heads,* as they are called). One was bounced into the front of the picture on the girl and the other reflected into the background, its direction controlled with "barn doors"— flat, hinged pieces of metal that mask off a portion of light according to how they are set. For this picture Smith used Kodachrome II, 105mm lens and Softar.

MODEL IN REPOSE [page 41]

Backlighting and the mood of his relaxed model inspired Smith to take this informal shot using a 35mm lens and exposing for ¼ second at f/3.5 on Kodachrome II. Not many people can hand-hold such an exposure and achieve suitable sharpness. If you run into a similar situa-

tion, a tripod is advisable. As for making an exposure reading, Smith used his Sekonic meter in its incident mode, holding the light-gathering dome in front of the face where it picked up the same illumination as the model's skin. Trying to make a reflected light reading by aiming the meter at the girl and set would have given him underexposure in the foreground, because the light from behind registers more strongly than the shadow area closer to the camera.

CONTACT STRIPS [pages 42, 45]

Study Smith's change-of-pace compositions and poses in the contact prints for an insight on how a professional's mind and eyes carefully control the camera. There is little duplication, and all the photographs were made with just two lenses; pages 43–45 with a 35mm lens, and some of page 45 with the same plus the 105mm lens with which he shot page 44. Smith doesn't own a zoom lens, a choice that is personal, but one the average photographer need not especially follow. The proliferation of fine short-range zooms on the market today is a real boon to users of single-lens reflex cameras. They run from 35mm-100mm, 45mm-125mm, 50mm-150mm, 65mm-135mm, and assorted ranges in between. Many are lightweight (one pound or less) and medium-priced.

New model short-range zooms are often introduced; be familiar with those that fit your camera before buying several single focal length lenses. Zoom lenses are versatile and modern optics make them as sharp as any other type of lens, but by their very nature, zooms provoke too much gimmickry by photographers. Often you may find yourself playing with the zoom adjustment when you should be concentrating on expression or spontaneity, so if you have one, beware of falling into its trap.

THE DAMNED
[pages 50–51]

For this fashion layout based on clothes from a movie, *The Damned,* Smith went on location to a stylish home where his large Thomas strobe was used to simulate mood-lighting in the movie. For the picture on page 50, one light was bounced off a 4x4-foot white flat reflector from a distance of 8 or 10 feet, as if it were coming from a large window.

For the pictures on page 51, Smith deviated from his usual technique by aiming his strobe *directly* at the models in order to make efficient use of a pink gel to tint the scene at left and a red gel for the photo on the right. A second light was bounced from a reflector for the picture at left to balance the direct light. Kodachrome II and a 35mm lens did the job in both cases. Colored light was chosen to amplify the feeling of decadence in the movie.

A selection of colored gels is sold by theatrical supply houses, and well-stocked camera shops may also carry them. For offbeat situations, gels are not expensive and are fun to play with. Make several exposures for each shot (with strobe or floor lighting); tinted light requires longer exposures, since it is weaker than white light. Keep a record of your tests, and revise your guide numbers. If you use an automatic strobe unit, however, it will make its own exposure compensation for colored lights.

WINDOW SHOPPING
[page 54]

Here is one of the rare times that Smith used a tripod, and the reason was twofold. First, he needed a 200mm lens to shoot across the street at the model in a window, and second, he needed a very tightly framed composition. Operating from a tripod guaranteed repeatable precision. The time was early morning and the light level required High Speed Ektachrome (ASA 160) for exposures between f/3.5 and f/5.6 at 1/8 second. Re-

flections were incorporated into the theme, so long distance communication with the model ("I used a lot of sign language!") and waiting for cars to pass were the only hangups.

LOVERS IN CARS
[pages 58, 59]

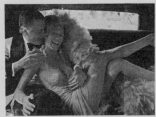

Along with the photo on pages 4–5, these two were from a fantasy picture story for *Cosmopolitan* called "Love in a Car," in which Smith did an outstanding job of making directed pictures look casually candid. He chose High Speed Ektachrome to shoot inside a car on page 58 with a 28mm lens at 1/15 second at f/5.6. He switched to Kodachrome II and a 105mm lens for page 59. It was a rainy day and he had to shoot quickly while the dog lay still, and while the mood of the model matched what he wanted. "The magazine was not interested in fashions as much as they were looking for an attitude," Smith recalls. The theme covered one girl who attracted seven different lovers, each with his own distinctive form of wheels, and the male models were typecast in keeping with their mode of transportation.

In an amusing footnote about professional stance, Smith mentioned that when he was shooting in a taxicab garage, "There must have been 30 guys sitting there watching the seduction! There were all sorts of comments, but the girl was a bit of an exhibitionist, and she really loved the game she was playing. I've learned to totally turn myself off on a location like that, to be absolutely isolated, so the big audience didn't slow us at all." It takes experience to maintain aplomb in any situation

that might be inhibiting, but professionals—those who are not temperamental anyway—manage to develop insulation, and their natural momentum gets them through most distractions.

FASHION IN THE FOG
[pages 62–63]

The fog was real, not the effect of a filter, and Long Island was the location. Smith was on assignment for *Cosmopolitan* with two days to do a number of shots. "When the fog rolled in," he recalls, "we just decided to go with it for the effect. It began to look like a scene in the Himalayas, and I had to use a wide-angle lens which got me closer to figures, or I wouldn't have been able to see them."

PERSONAL DOCUMENT

From page 64 through page 71 you see a photographic sketchbook, representing personal images Smith made in Paris and the West Indies. One of the West Indies pictures appears on pages 2–3. Opening on page 64 is a little still life arranged as a visual memoir with whimsy, involving symbols of other trips and items he wanted to remember later to bring back feelings of that moment.

The rest of the pictures demonstrate the free-flowing imagery that Smith shoots for himself, showing that his mind is never still. The natural light of his room was an inspiration because it showed form softly, and to this he added the interrupting shapes of flowers for their beauty and design. Most of the pictures were taken with a 35mm lens except the photographs on pages 66–67 and page 69. Smith notes, "When I travel, I hate to carry much gear, so I take one Nikon body and maybe two lenses. Sometimes I'll take two bodies, one for color and one for black and white, and three lenses at the very most. In the photos on pages 66–67 and 69, I obviously had the 20mm lens along. I can tell by the perspective it rendered of the room and the relationship of the figure and tray on page 69."

MOTHER AND DAUGHTER
[pages 89–96]

Smith's delightful and intimate pictures of an actress-mother and her daughter were shot in a large enclosure of white sheets hung all around a bed in the studio. A bank (or cluster) of six floodlights on stands was placed on either side behind the sheets which diffused the light very evenly. Exposures on Tri-X were made at 1/125 second at f/8.

By this time you have shared all of J. Frederick Smith's relatively limited collection of techniques and probably discovered there's nothing you cannot simulate, perhaps on a smaller scale in terms of lights or sets, in your own surroundings.

Over the years J. Frederick Smith has composed many stories that are privately bound and limited to an edition of two—one for the subject, one for the photographer. Among his most remarkable is the story of a love between a mother and her daughter.

A young actress friend asked Smith to document the private time she and her five-year-old spent together. To do it, he enclosed their bed in a tent of white sheets through which he diffused the light of 12 floodlamps for soft, even illumination. Feeling secure inside this cocoon, the subjects played for five hours, ranging from sisterly playfulness to a deep tenderness. Smith shot through peepholes in the sheets and from positions inside the tent, using Tri-X at 1/125 second at f/8, and printed the pictures through frosted acetate to reinforce the high-key, almost ethereal feeling of the relationship between mother and child.

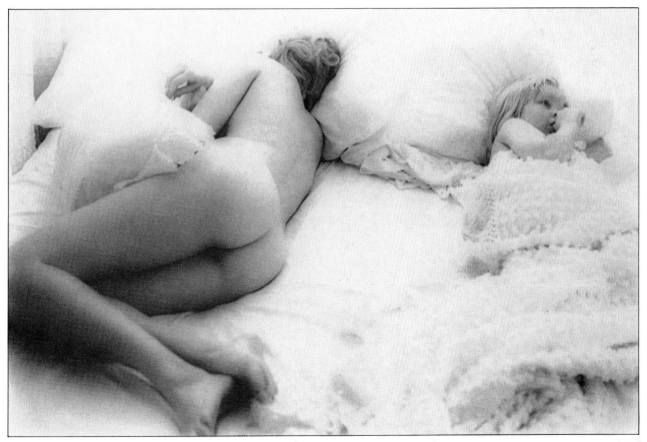

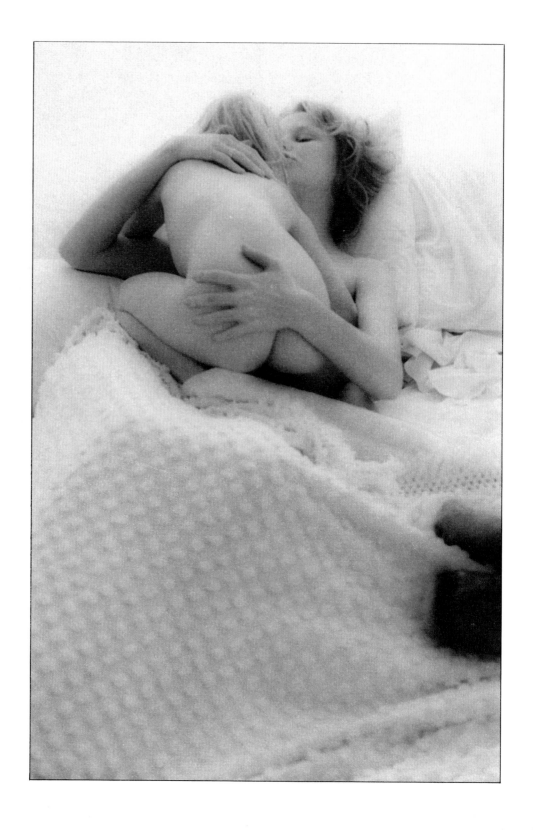

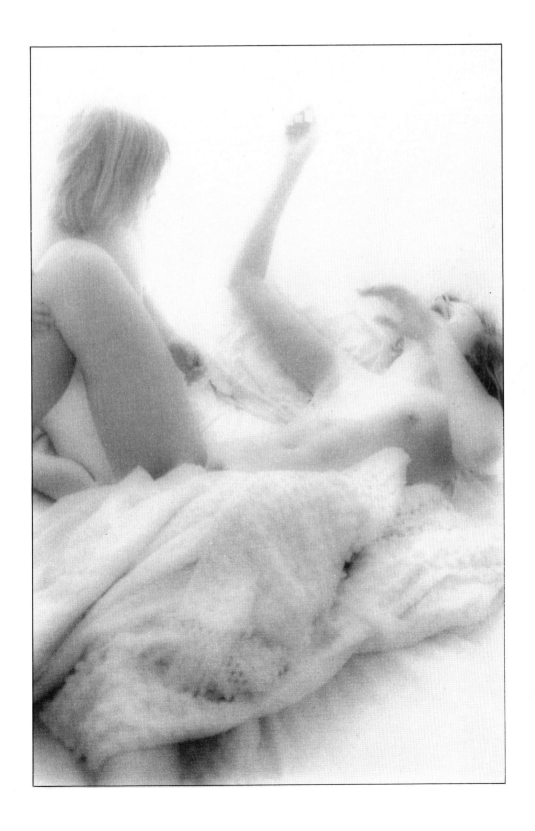

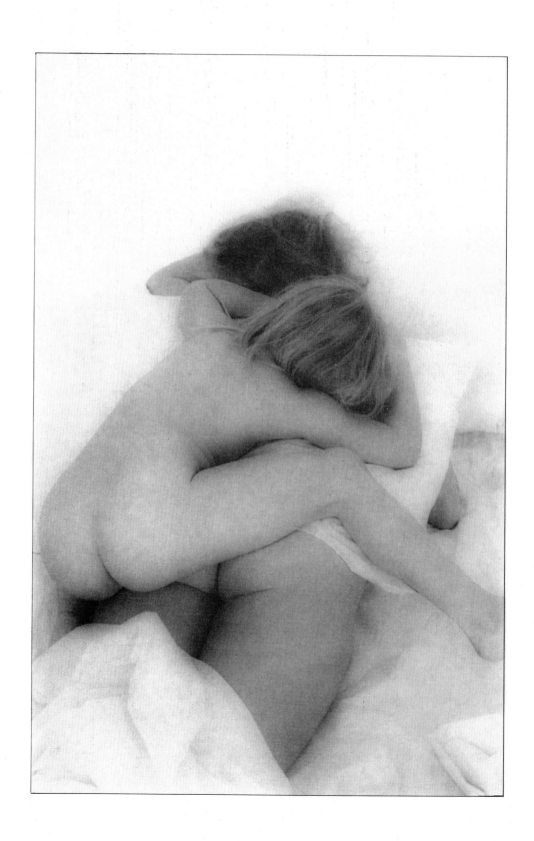

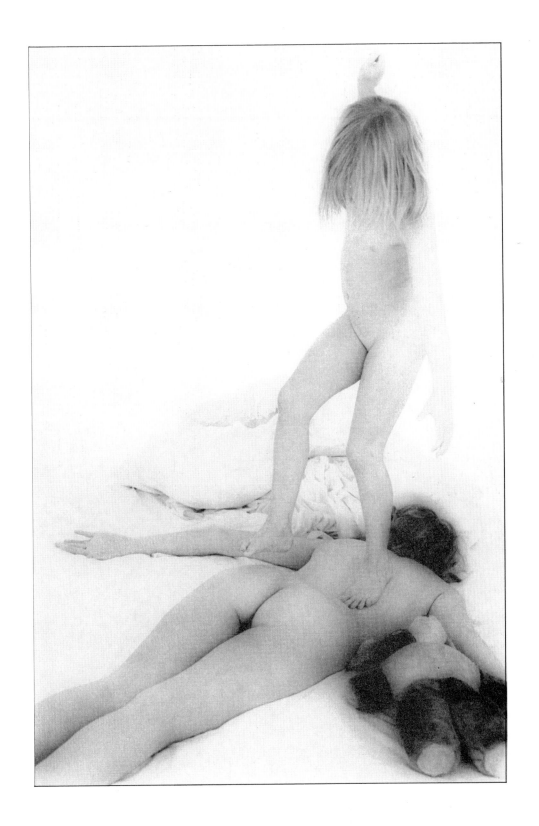

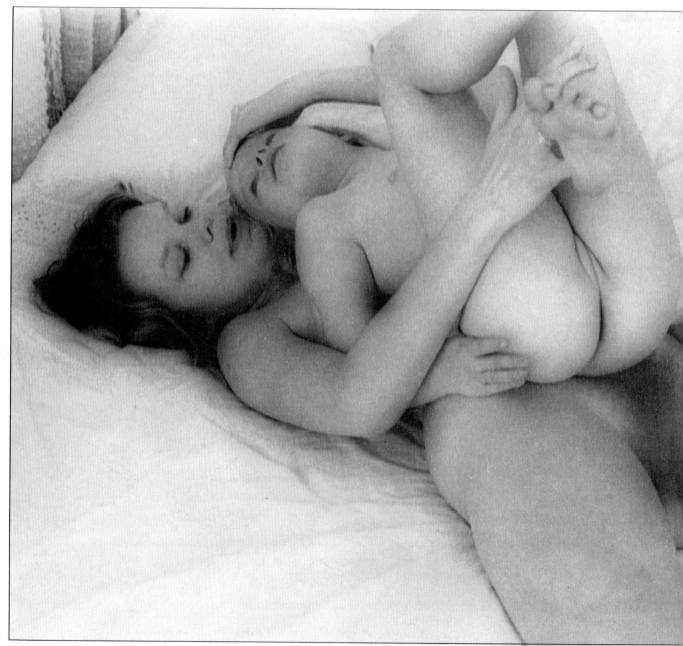

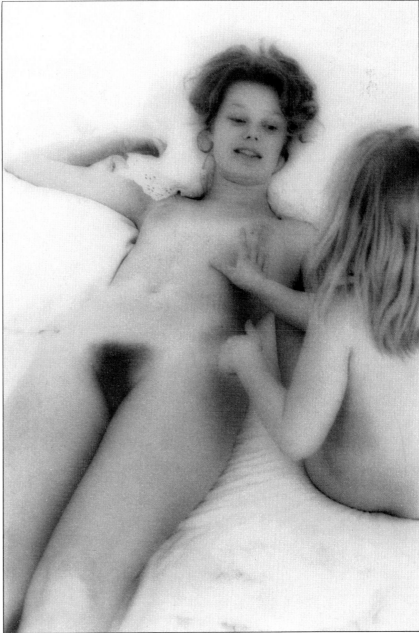

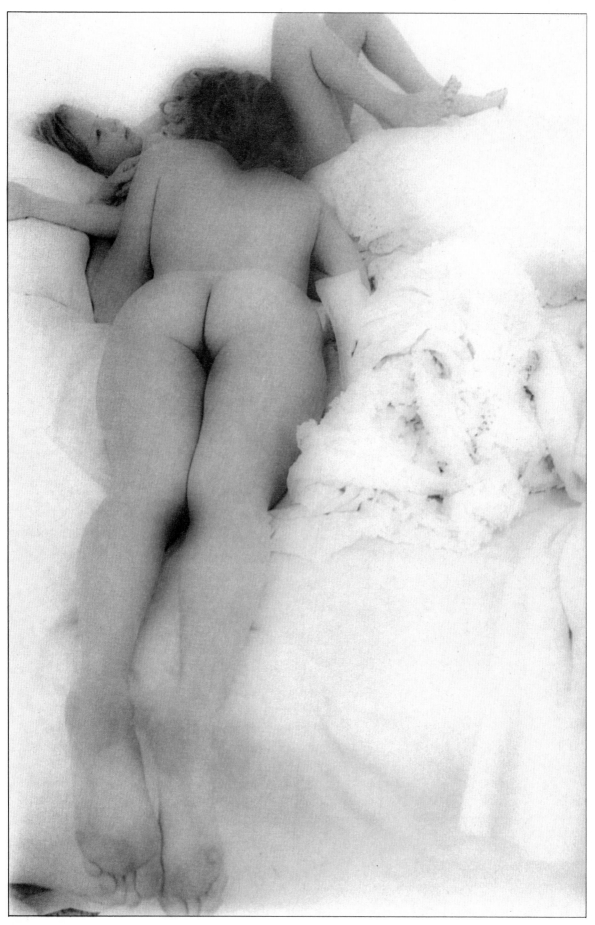